FRAMPTON COTTERELL & COALPIT HEATH
REVISITED

FRAMPTON COTTERELL LOCAL HISTORY
SOCIETY WITH IAN HADDRELL

The
History
Press

Back cover: Mr George Colthurst Hewitt and his sister Miss Sarah Ellen Hewitt of Serridge House, photographed by their niece, Dorothy Hewitt, on Tuesday, 27 June 1911. The occasion is the celebration of the Coronation of King George V, held on the Manor School playing field. The *Bristol Times and Mirror* reported that: 'At seven o'clock a Coronation Mug and bun was given to each child and a bun to the mothers, these being kindly given by Mr G.C. Hewitt and Miss Hewitt who were heartily thanked by the vicar.'

First published 2012
Reprinted 2014

The History Press
The Mill, Brimscombe Port
Stroud, Gloucestershire, GL5 2QG
www.thehistorypress.co.uk

© Frampton Cotterell Local History Society with Ian Haddrell, 2012

The right of Frampton Cotterell Local History Society with
Ian Haddrell to be identified as the Authors
of this work has been asserted in accordance with the
Copyrights, Designs and Patents Act 1988.

British Library Cataloguing in Publication Data.
A catalogue record for this book is available from the British Library.

ISBN 978 0 7524 6469 5

Typesetting and origination by The History Press
Printed and bound in Great Britain by
Marston Book Services Limited, Oxfordshire

CONTENTS

ACKNOWLEDGEMENTS

Derek Andrews; Gillian Baum; Stella Beecher; Mr and Mrs Andrew Bennett; Andrew Brander; *Bristol Evening World*; Victor Close; Sally Cooke (*née* Cottingham); John Cornwell; Peggy Crew; Shirley Crewe; Clive Dando; Diana Davis (*née* Stabbins); Bob Drew; George Drew; Peggy Drew; Frampton Cotterell Cricket Club; Frampton Cotterell Royal British Legion; the *Gazette*; Pauline Gearing; Goods and Chattels of our Forefathers; Bernie Green; Steve Grudgings; Ian Haddrell; Arthur Hancock; Alec Harding; David Hardwick; Raymond Hawkins; Graham Hayter; Peter Holmes; David and Susan Holway (*née* Boulton); Ray Hooley; Mike Jay; Tony Killbe; Sylvia Lewis (*née* Cook); Colin Maggs; Richard Maggs; Anne Matson; Jean Mitchell; John Moore; Moseley Railway Trust; Stuart Moseley; John Nelmes; Robert Nelmes; Tony Nelmes; David and Christine Nicholls (*née* Lewis); Alvan Panes; Shirley Pitt; Ian Pope; Albert Rogers; Cherry Ryan; John Scantlebury; Science Museum Pearson Collection; Charlie Smith; Janet Smith; Margaret Smith (*née* Loosley); South Gloucestershire Mines Research Group; Jeffrey Spittal; John Oxley Library, State Library of Queensland; Maureen Thompson (*née* Elson); Trevor Thompson; Mike Tovey; Marie Walters (*née* Nicholls); Bob Williams; Terry Williams; Daisy and Fred Woodruff; and the numerous past and present residents of Coalpit Heath and Frampton Cotterell who have identified so many individuals in the photographs.

Every effort has been made to identify copyright holders of illustrations from published materials, but we apologise to anyone overlooked in our search, or to photograph owners, should their names be omitted from the above list.

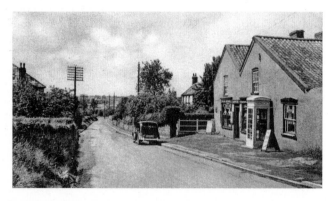

A 1940s photograph of Church Road, deserted except for one Bristol-registered car parked outside the taped, anti-blast windowed post office and shop. The proprietor is Mr Edwin Turner, who in addition to his postal duties runs a grocery shop that also sells, according to the advertising, Lyons ice cream and Wills Gold Flake cigarettes. The photographer is standing at the junction with Ryecroft Road looking west. There are telephone poles to the left-hand side and, on the right, West Gloucester Power Co. electricity poles are distinguishable by their pointed caps.

INTRODUCTION

NATIONAL HISTORY, LOCAL HISTORY, FAMILY HISTORY

During my lifetime (I was born in 1937) there has been a revolution in the content, coverage and methods of studying 'history'. When I was at school in the early 1950s, history was still overwhelmingly political, the proverbial 'kings and battles' stuff. I remember suggesting to the Head of History that surely the people as a whole ought to be included, only to receive the acid reply, 'You have a very peculiar idea of history, Moore.' Even when I moved on to undergraduate study in the mid-'50s, most History degrees were still mainly political – though the University of London's History degree offered options in English economic history, and the special subjects included the Economic and Social History of Tudor England. Economic and social history was certainly being taught at postgraduate level, and the *Economic History Review* had been published since the 1920s. Local history had been taught to extramural students and Workers' Educational Association classes since the 1930s – one of its pioneers being W.G. Hoskins, who founded the first Department of English Local History at the University of Leicester. His three classic books, *The Making of the English Landscape* (1955), *The Midland Peasant* (1957) and *Local History in England* (1959), established local history as a respectable subject and inspired many postgraduates, including myself, to study local topics. Family history did not exist: genealogy was the preserve of antiquarians mostly interested in the descent of armigerous families (families bearing coats of arms).

This situation began to change in the late 1950s and the early 1960s, with the rise of the social sciences (including economic and social history) to academic respectability and the great expansion of university education following the Robbins Report of 1963. By the 1970s, very few universities did not have a department of economic or economic and social history. Many had undergraduate courses in the history of the local region, encouraged by the social science approach which emphasised sample studies. Although the great expansion of British universities ended with the accession of Mrs Thatcher, the resulting re-unification of departments of 'old' history with departments of 'new' economic and social history did not result in the downgrading of economic and social history. Another unfortunate result of Mrs Thatcher's government was the decision to axe central government support for extramural courses: the previous two decades had seen a great expansion of extramural local history courses (as at Frampton Cotterell from 1971) and the creation of new local history societies (as at Frampton Cotterell and Almondsbury, both of which are still thriving today). Local history had now come of age.

Other developments had also occurred since the 1950s, notably the establishment of many county and borough archive offices. An important step for preserving local records was the Church of England's Synod 'Parish Records and Registers Measure' of 1971, which required Anglican parsons either to install fire- and water-proof safes for their records or to deposit these records in the local record office: thus most local parish records

in the Frampton area were deposited in the Bristol Record Office, which was the recognised place of deposit for the Bristol diocese. Regrettably, a few parsons did not obey the measure, often with disastrous results: the Iron Acton records, which had been in good condition when Jeffrey Spittal and I consulted them in the 1970s, were a water-soaked spongy mess when they were finally deposited in the Bristol Record Office.

The enhanced availability of both parish and pre-1858 probate records in diocesan record offices had another important result: genealogy, previously the preserve of those interested mainly in upper-class families, now widened its scope. One of the significant results of the expansion of local history was the realisation that local people could study their own ancestors, most of whom would be inhabitants of their own or neighbouring parishes. This development was encouraged by changes taking place at national level, notably the foundation of the Cambridge Group for the study of population by E.A. Wrigley and others, who realised that advancing the history of population in England required the co-operation of academic and local historians. Many parish registers were systematically tabulated on standard forms and sent to Cambridge for analysis, which finally resulted in Wrigley and Schofield's national study – *The Population History of England, 1541-1871* – in 1981. The Cambridge Group also inspired the foundation of the journal *Local Population Studies*, as a forum linking national academic and local population historians. Local historians as well as postgraduate students were encouraged to try to reconstruct local families generation by generation, an effort finally resulting in the publication of *English Population History from Family Reconstitution, 1580-1837* by Wrigley et al. in 1997. Even though experts have queried some of the processes, the work of the Cambridge Group put researching family history firmly on the map as a respectable activity. The earlier foundation of many local history societies was now paralleled by the foundation of numerous family history societies, such as our own local Sodbury Vale Family History Group. Furthermore, the Federation of Family History Societies was founded; this organisation publishes many useful handbooks for family historians and is still going strong today.

Simultaneously, there was a technical development which was to affect all subjects: the 'computer revolution'. Initially, this required the use of large mainframe computers often occupying several rooms, but the development of the IBM PC in 1981 as an industry standard led to other firms offering IBM-compatible machines. By the late 1990s, IBM-compatible PCs had fallen in price and were the basis for rapid technical developments which have continued today, with increasingly user-friendly software. Most local and family historians can now afford a PC for gathering, sorting and analysing local data, and the acquisition of data in record offices and libraries is now much easier using a laptop or notebook computer. An additional development has been the evolution of the internet, which now allows access to libraries and record offices online. But beware of the web as a research tool – not all the information available is necessarily correct; keep your critical faculties alive.

The history scene in 2012 is radically different from that of 1951. National history is alive and well in British universities and covers a far wider range of types of history than earlier; it also co-operates with local and family historians in the regions. Local history at both national and local levels is flourishing, while genealogy, previously a predominantly upper-class hobby, has been transformed into family history, which looks at all the local people in its community in the past. Despite the continued lack of support from national government, in 2012 history in all its guises is thriving.

John S. Moore,
President of Frampton Cotterell Local History Society,
2012

1

FRAMPTON COTTERELL

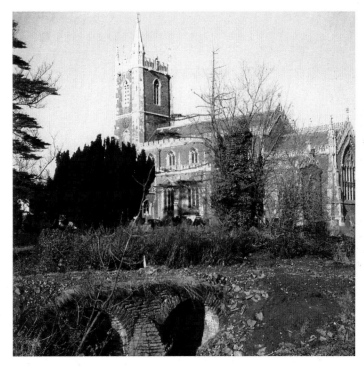

St Peter's Church and the old stone footbridge over the River Frome, photographed in January 1966, just prior to the bridge's demolition for road improvement works. The parapets have been removed but it is still in use by the workmen of the highway department of Gloucestershire County Council, who are constructing a new bridge in association with road widening and re-alignment. Traffic was diverted over a temporary Bailey bridge.

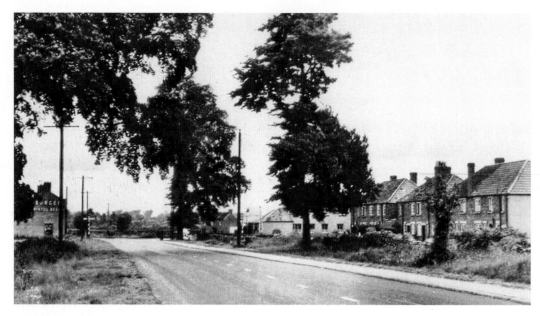

Bristol Road and the Cross Hands Inn, North Corner, Frampton Cotterell. The council houses on the right-hand side were built in the 1930s on what was previously Frampton Common. The public house with Georges Bristol Beer emblazoned on the gable end, situated on the corner junction of Bristol Road with Perrinpit Road and Church Road, was, at the time of this photograph, the Cross Hands. In later years its name changed to the Western Coach House.

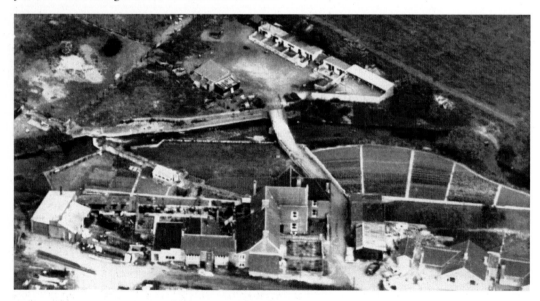

An aerial view, taken in 1961, of properties and land at the end of Mill Lane. Drew's premises are in the bottom left of the photograph, with the forge chimney protruding through the workshop roof. Albert Drew purchased buildings and land from Fred Cook of Winterbourne and set up business as an agricultural engineer and blacksmith. This whole area was once owned by Mr Cook, whose cattle-haulier nephew, Alfred Frederick Cook, known as Sonny, resided in Mill House (centre of picture). His piggery on the other side of the River Frome was accessed via an old bridge.

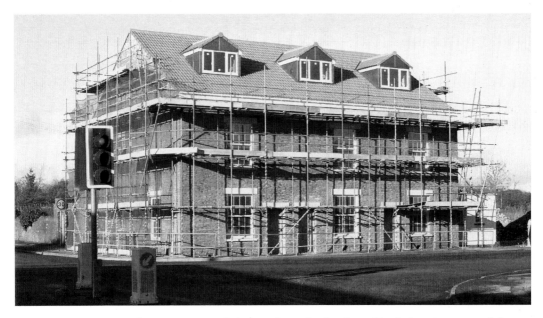

A sign of the times as the Western Coach House, formerly the Cross Hands Inn, is converted from a public house to three individual houses in 2006. The change in social circumstances, coupled with drink-drive laws, secured the fate of many public houses; the Western Coach House was no exception. Situated on the crossroads of Bristol Road, Church Road and Perrinpit Road, it is practically at the geographical centre of the parish of Frampton Cotterell.

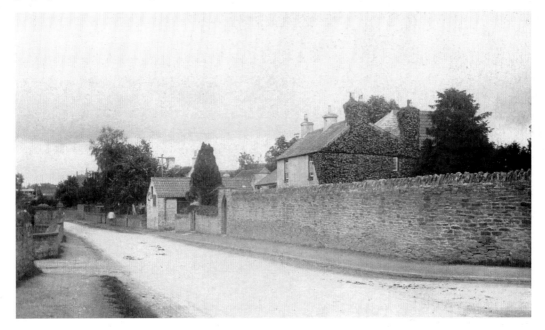

Looking down Church Road, with School Road off to the right and St Peter's Church tower just visible in the distance, behind the trees. The large pair of stone pillars mark the entrance to the Brookman residence, formerly Parsonage Farm. At the beginning of the twentieth century, clusters of cottages to the left and right of the road were known as Belcher's Barton and Little London respectively.

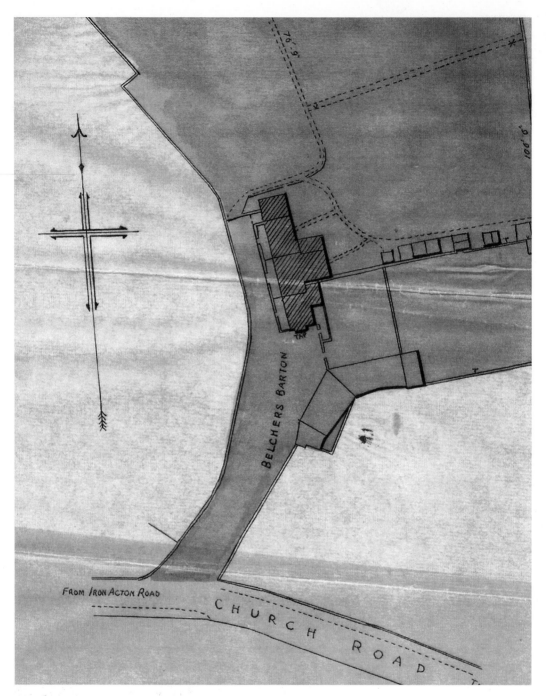

FROM IRON ACTON ROAD

BELCHERS BARTON

CHURCH ROAD

Little London, a group of cottages off Church Road, was thought to have been the dwelling place of hatters from London in the nineteenth century, hence the name. However, sales documents and accompanying plans, dated 17 December 1887 and 2 September 1942, record the area as Belcher's Barton. Indeed, in the 1901 census, Belcher's Barton and Little London appear as separate addresses; there are six cottages at the former locality between the Globe and Parsonage Farm, whilst Little London has three homes positioned on the opposite side of Church Road, near the police station and the post office.

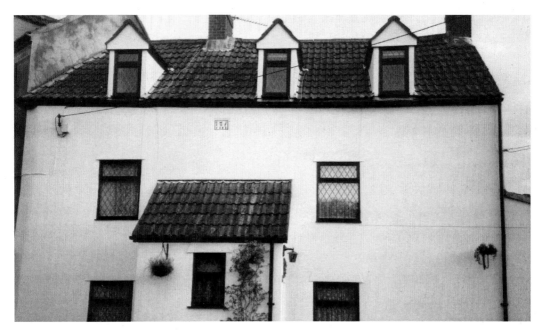

The initialled 1683 date stone on the west elevation of the row of cottages in Belcher's Barton most probably refers to the Millets, a seventeenth-century Frampton Cotterell family of substantial means. The capital M represents the surname, whilst the letter F may be Frances, whose inventory upon her death in 1702 describes her as 'a lady of considerable wealth and possessions, including cheese and bacon of which she is a merchant and producer'. Both foods were traditional produce of Frampton Cotterell and Gloucestershire in the Middle Ages.

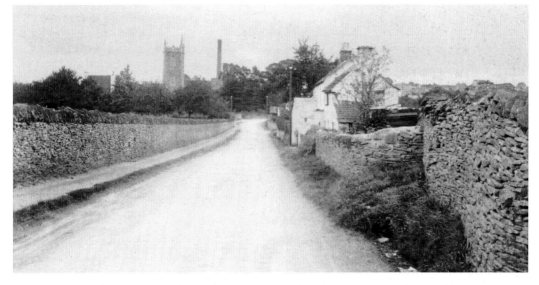

Church Road, at the beginning of the twentieth century, has the appearance of a rural lane, with three prominent features in the distance. The roof of the Globe Inn, St Peter's Church tower and the distinctive chimney of the West Gloucester Water Works Co. are clearly visible. The building on the right is Church Farm, which together with its fields was destined to become part of the Bensons' new housing estate. The fine examples of local pennant sandstone walls are now long gone.

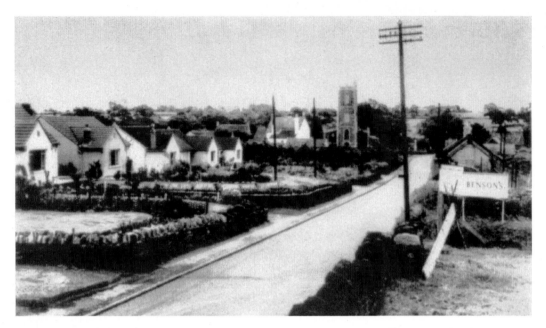

The 1960s saw the beginning of the urbanisation of Frampton Cotterell. Among the first of such developments was the Church Farm estate built by Benson Bros of Filton. The photograph shows the developer's sign before work started in earnest, and before Church Road was re-aligned and widened.

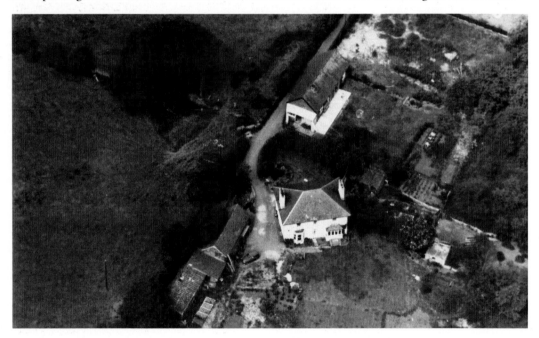

An aerial view of Park House, situated at the end of Park Row, Frampton Cotterell. Built in the 1830s, it was purchased by Henry Herbert Harding from the Egelstaff family in 1905. Harding, from Stapleton in Bristol, was a poultry farmer who expanded his business by selling a wide variety of fruit, flowers and vegetables locally. Harding also planted a great variety of fruit trees in the area: apple, pear, plum, damson, fig, peach and nectarine.

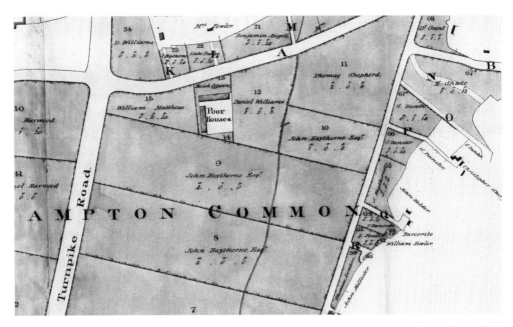

A section of the Frampton Cotterell enclosure map surveyed by Young Sturge of Bristol in 1831 to show 'Commons and Waste Lands'. The scale of the original map is 40in to 1 mile and shows some buildings (including poor houses), names of landowners and acreages. The area illustrated is Frampton Common, near the crossroads of Church Road, Perrinpit Road and Bristol Road (Turnpike Road on the map).

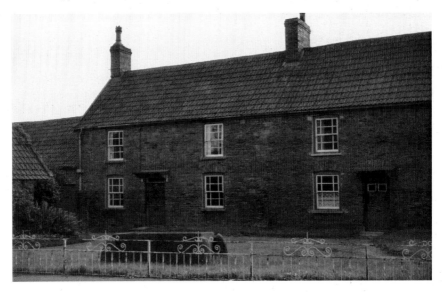

Two conjoined cottages in Church Road, built to house the parish officers, were erected at the time when parishes throughout England were responsible for the destitute of their communities. The one on the right was built in 1823 at the same time as the poor house which is immediately behind it. The house on the left, built in 1825, was until 1935 a public house called the Stag's Head. Two interesting features are the stone canopies over the doorways and the large stone carved horse trough, both fine examples of an ancient local craft now consigned to history books.

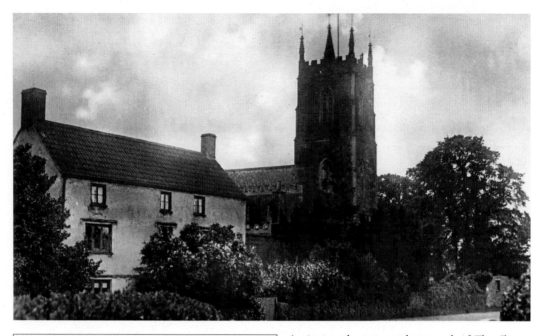

A nineteenth-century photograph of The Close, known today as Mill Lane, showing the north elevation of the tower of St Peter's Church and the front elevation of a large three-storey building which at one time was a public house called the New Inn. The building had a large meeting room and it was here that meetings of the parish vestry and the Feltmakers Friendly Society (an association for felt and hat workers, which in many ways was the forerunner of the trade union movement) were held.

An extract from St Peter's Church archives, published in the church magazine. The Account of the Expenses for the year 1764 contains a number of interesting payments, particularly the 6d paid for two 'Hedgehogge'. Unfortunately, the use they were put to is not recorded. Evidently the village stocks and whipping post were still in use during that period, as 1s 3d was required for their repair in 1787.

Parish - FRAMPTON COTTERELL - Extract from O.S. 1935

CLYDE ROAD

Goosegreen

RISING SUN INN

429
4·515

SOUTH VIEW

RYECROFT ROAD

WOODEND ROAD

447a
·353

45 Yds.

A

C

451
·685

452
3·812

B

FOOTES LANE

G

F

D

E

A. Matting wicket 45 Yd radius from Centre.

B. Soccer. 80 x 50 Yds.

C. Net Ball 100 x 50 Ft.

D. 2 hard tennis courts 114 x 102 Ft.

E. Childrens Corner.

F. Car Park.

G. Village Hall.

The field on the corner of Beesmoor Road and Woodend Road, known at the time as the allotment field, was purchased by Edgar Lewis for £520 at a sale at the Globe Inn on 20 August 1946, and was conveyed to four trustees – Tom Hughes, Joseph T. Roach, Gilbert Moseley and Edgar Lewis – on 26 August 1946. The original plan for the field included cricket and football pitches, netball and tennis courts, a children's corner, car park and a village hall. In the summer of 1948, the field was levelled by a bulldozer and sown with grass seed (given by Mr Alfred Nichols of Oxbridge Farm) under the supervision of Mr Gilbert T. Baker of Park Farm.

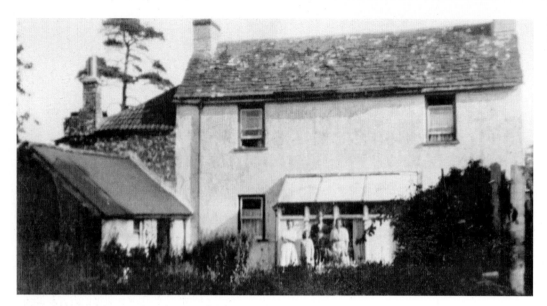

Number 31 Rectory Road, the home of the Oborne family, photographed in the 1940s. Lewis Herbert Oborne (1902-1970) and his wife Evelyn Blanche, *née* Sims (1900-1983) are standing outside their house with daughters Pamela (born 1928) who married Charles Terry, and Evonne (born 1940) who married Robert Nelmes. In years past, before the River Frome was dredged and lowered in the 1950s, it was not unusual, after periods of prolonged rain, for the ground-floor rooms of riverside cottages such as this to flood up to window sill level.

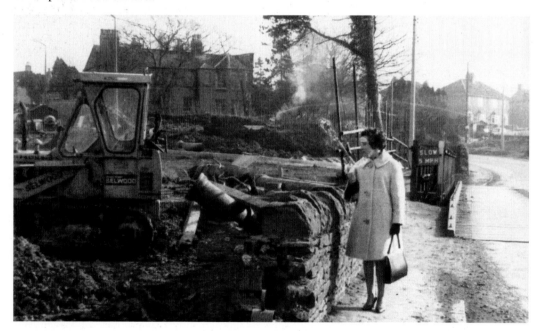

The rapid urbanisation of Frampton Cotterell in the early 1960s significantly increased traffic in Church Road, requiring Gloucestershire County Council to improve the road's capacity. Widening and re-alignment, together with the construction of a new bridge, commenced during September 1965. Work was completed and the new road opened for traffic in the latter half of 1966.

The old stone mill bridge over the River Frome was one of four river crossings in Frampton Cotterell parish between Nightingale's Bridge and Cog Mill. The bridge doubled in length in 1980; the original stone arch was retained, with the east buttress (now in the centre of the river) being reinforced with new foundations. The additional span was constructed of steel and concrete, and the widened river doubled the flow capacity of the Frome.

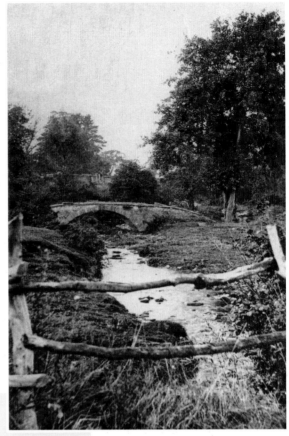

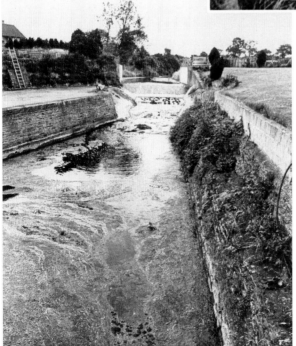

In 1980, extensive alterations were made to the weir on the River Frome. The photograph shows the newly constructed weir and side walls, which incorporated flow meters; the new riverbed was laid with large rocks to create turbulence for water aeration. The contractor for the work was Cotterell, O'Brien and Bates Ltd. The new wall supporting the garden of Mill House was built by Mr Charlie Smith, who was at that time conductor of Frampton Male Voice Choir.

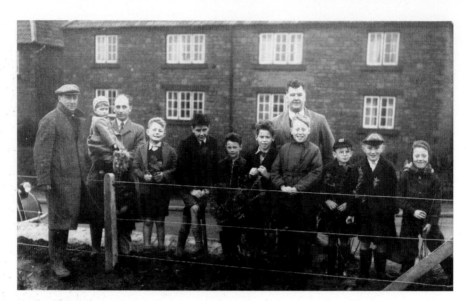

Local children helping members of the Beesmoor Road Recreation Field Committee to plant hedges, *c.* 1955. Woodend Road is in the background. Adults from left to right: Gilbert Baker, Arthur Player, Arthur Nelmes. Children: Diana Player, Derek Player, Anthony Dando, John Nelmes, Malcolm Pritchard, Alvin Nelmes, Peter Davis, -?-, -?-, -?-.

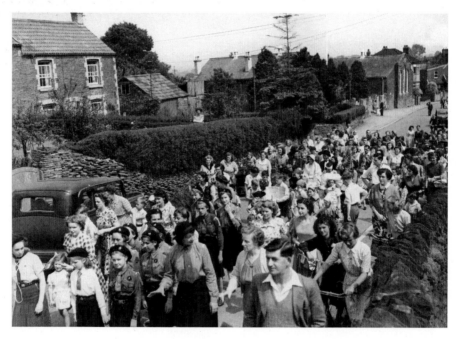

Part of the Frampton Cotterell Carnival procession moving up Woodend Road in the 1950s, with the Council School in the distance. Margaret Dando is the Girl Guide next to the Guide captain, with Maureen Dutfield (hand on chin) just behind. Graham Brown is the man in the foreground, Mrs Hughes is to his right, and Iris Pritchard is the lady walking behind on the pavement. Others who have been identified in the picture are Mrs Barbara Corcoran, Mrs Thomas, Olive Skidmore, Mrs Cook and Wendy Cook. Mrs Green is the lady observing the proceedings from her front garden.

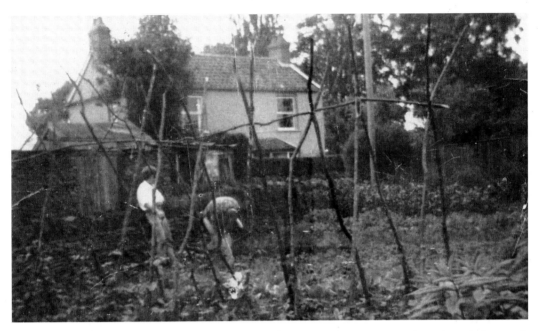

Peggy Drew and her eldest son Mervyn working in the garden of their Gladstone Lane cottage around 1970. The cottage was purchased by Alfred Drew in 1936 (six years after his marriage to Winifred May Eaves) and afterwards by their son Dennis and his wife Peggy (*née* Lowe). Two substantial properties were built in 1994 and 2002 on the site of the cottage and its extensive garden. Connie Holbrook's Ryecroft Road cottage is in the distance.

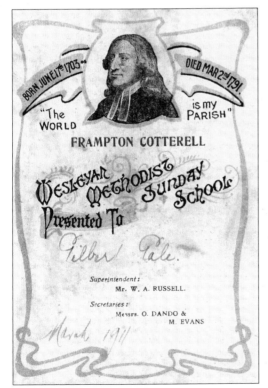

This bookplate, dated March 1911, was presented to Gilbert Gale by Wesleyan Methodist Sunday school. Gilbert John Gale was born 22 April 1896 at Frampton Cotterell, the son of John Gale (a timberman at Frog Lane Colliery) and Clara Gale (*née* Williams) of Frampton End. Gilbert died in March 1985. Wesley Chapel was built in 1821, on ground now occupied by No. 153 Church Road, by followers of a group of dissentient Methodists. It closed in December 1967.

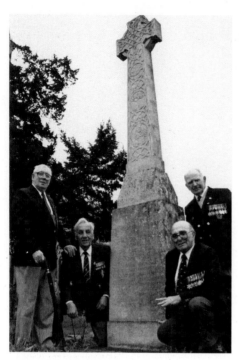

Members of Frampton Cotterell Royal British Legion at the war memorial in St Peter's churchyard. From left to right: Ray Smith, Norman Tremlin, Arthur Soper, Bill ?.

Ray Smith, a former chairman and treasurer, was president of the local branch from 1986 to 2006. The memorial was erected by public subscription in 1922 in the form of a 14ft-high cross of Portland stone, engraved with three symbols on the west side – a dove, a tree and a whale – representing air, land and sea: the three branches of the armed forces. Arranged by the date of their death are the names of twenty-one servicemen killed during the First World War and two servicemen who died during the Second World War. In 2005, the parish council refurbished the memorial and inserted a new panel of Portland stone with the First World War names inscribed afresh.

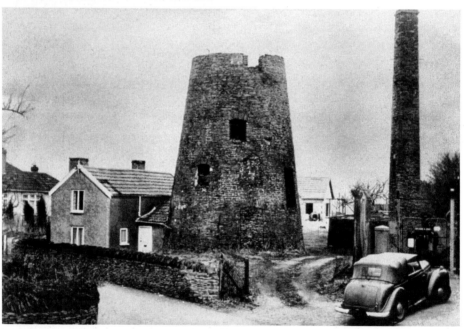

A prominent feature of Frampton Cotterell since 1825 has been the windmill at the south end of Brockridge, at the intersection of Ryecroft and Woodend Roads. This 1950s photograph shows the mill to be completely redundant, with about 6ft of masonry removed. The chimney to the right is a relic from when the sails were removed and the driving of the mill stones was converted to steam power sometime in the 1860s. A 1301 survey states that Frampton Cotterell had three watermills and a windmill.

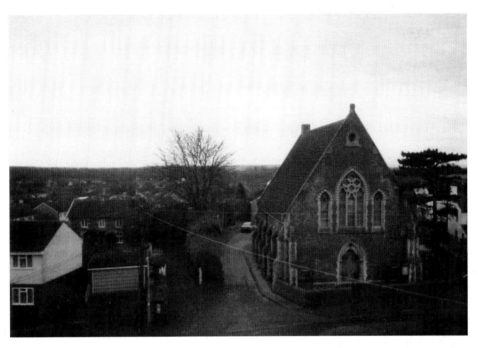

An unusual view of Mount Zion Chapel, taken from the top of the windmill. It was built in 1873 and replaced the original 1795 Zion Chapel, which is behind this building and is today used as a church hall.

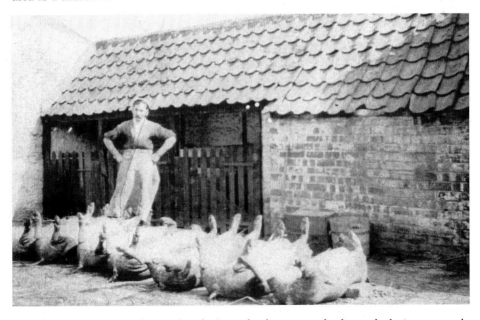

The slaughter man stands over his day's work; these recently despatched pigs are ready to be butchered and sold in the local shops. Hygiene doesn't appear to be too much of a priority, as there is no cold slab, just a thin scattering of straw. The precise location of the slaughterhouse in Woodend Road has not been established, but is thought to have been adjacent to the Bunch of Grapes public house.

Towards the end of the 1990s, land surplus to the needs of Brockridge Infants' School in Woodend Road was acquired by the parish council. The site consisted of an old building, built in the 1940s as a canteen for the school, which was converted into a swimming pool in 1974 with the help of inmates from Leyhill Prison. The pool closed in 1990 and a new building, the Brockeridge Centre (which opened 6 May 2000), was erected as the council's Millennium Project.

A cottage that stood in Adam's Land, to the right of the former Co-operative Society's manager's house, Woodend Road. Its last inhabitant prior to demolition in 1984 was Mrs Nora Isaacs. Photographed in July 1984, this is one of a number of pictures taken by Clive Dando to record buildings in the vicinity of the former Co-op before they were cleared for housing development.

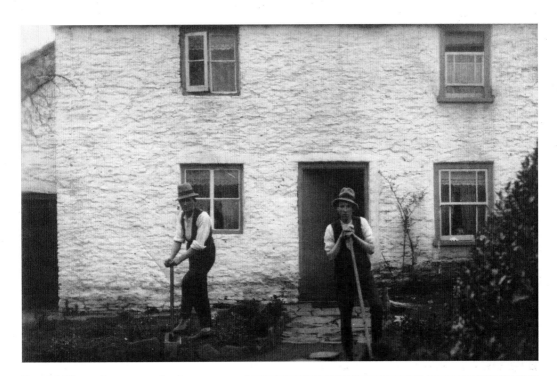

Two 1920s gardeners pose for the camera outside a cottage in what is believed to be The Land, Frampton Cotterell. Local pennant sandstone has been used as a path in front of the cottage and as borders for the flowerbeds.

Fanny Horder stands outside her cottage in Ryecroft Road in 1910. Fanny, born in 1867 in Winterbourne, was the daughter of George and Emily Bowyer (*née* Hollister). She married George Horder, a coal miner from Frampton Cotterell, in 1898; the couple had three children, Edward, Georgina and Elizabeth. Georgina, born 18 July 1901, married Isaac Nicholls in 1925 and for many years worked for Ryecroft Road neighbour Daniel Luton in his butchery business.

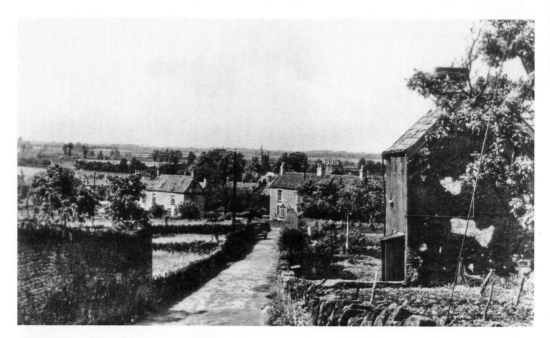

Looking down Goose Green towards cottages in Clyde Road, with St Peter's Church and open fields in the distance. Possibly taken around 1945, the building nearest the camera appears to be in a poor state of repair, as were many of the properties in the village at that time. Mrs Eastman was a one-time inhabitant of the property.

Harold Green with the family dog 'Blackie' outside the Green family home, No. 14 Upper Stone Close. Harold, born in 1924, the son of Alfred George and Alice (née Smart), was killed in the Second World War. George, as his father was known, owned extensive greenhouses opposite their house in the 1950s, where he grew vegetables and chrysanthemums.

2

COALPIT HEATH

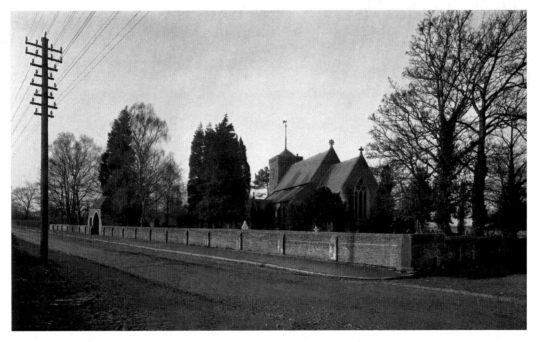

Badminton Road – or Main Road as it was known at the time – has the appearance of a country lane in this fine Dorothy Hewitt picture, taken *c.* 1905. The church is St Saviour's. At the time there were no street lamps, with no electricity or gas in the houses, and a ditch or dyke ran along the length of the main road. Bell Road later developed to the right of the boundary wall.

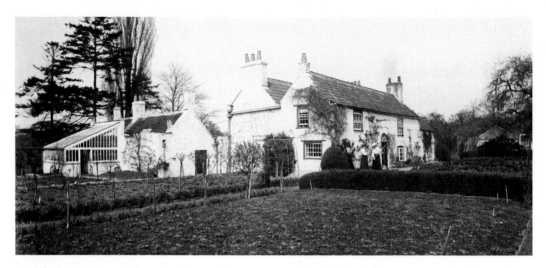

Heath Cottage, the home of Anne Hewitt – the last surviving daughter of William and Elizabeth, and aunt of Dorothy Hewitt – *c.* 1905. Anne was born at Heath Cottage in 1826 and remained a spinster until her death in 1914, aged eighty-eight. An extract from a 1914 issue of *West Country Churches* reveals: 'A regular attendant at the church [St Saviour's], Sunday by Sunday is Miss Hewitt, perhaps the oldest member of the congregation, who sixty-seven years ago was the first organist and whose father was largely instrumental in providing a church and vicarage in the district.' A stained-glass window in St Saviour's Church is dedicated to Anne, in which two saints are given prominence – Saints Cecilia and Dorothea, the patron saints of music and gardeners, reflecting the two main passions of her life. In this picture, Anne can be seen standing to the left of the two ladies attending to the garden.

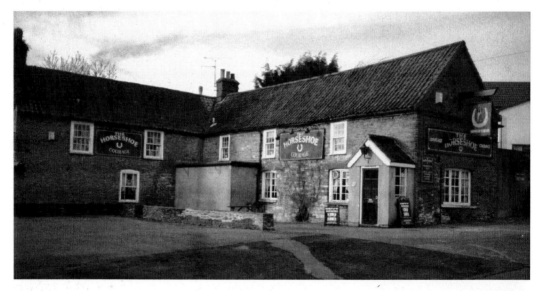

The Horseshoe Inn, The Causeway, towards the end of its existence as a public house. Some of the building's features date back to the seventeenth century. The 1738-1740 List of Licences for South Gloucestershire records a George Richard as licensee of the pub, and members of the Holder family – Samuel, Henry and Robert – were landlords of the Horseshoe from the 1830s to the early part of the twentieth century. The L-shaped pub was the subject of a long campaign in the 1990s to save it from demolition, but in 2004 it ceased trading and was converted into private dwellings.

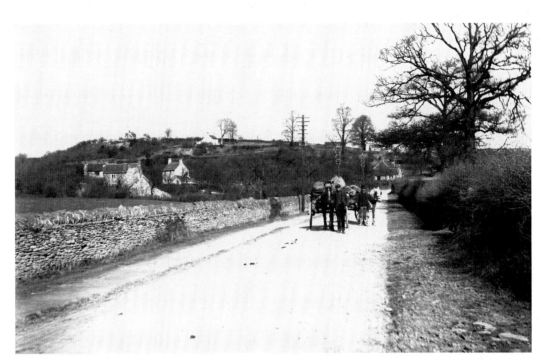

Looking north-east from Kendleshire along Badminton Road, with Ivory Hill Farm in the distance, *c.* 1905. The cottage on the left-hand side is shown clearly in the following photograph. The two hauliers have been persuaded to pose for the photographer, Dorothy Hewitt, so she can obtain clear images.

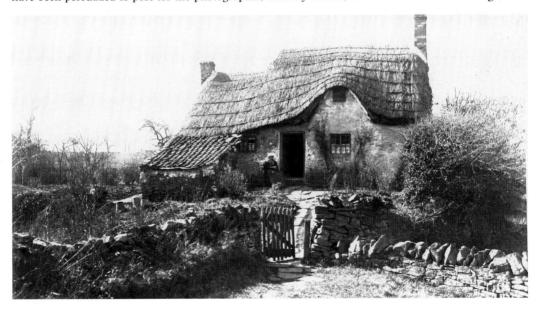

Dorothy Hewitt's study of a thatch-roofed dwelling with eyebrow window and pan-tiled lean-to wash house at Huckford, Kendleshire, near what is now Badminton Road, The rhubarb pots are empty and the garden is overgrown; perhaps it is too much for the old lady to cultivate. The original glass plate pocket says 'Mrs Horton's cottage', and the 1901 census records a Martha Horton, a widow aged seventy-five, living in a two-roomed property in Kendleshire.

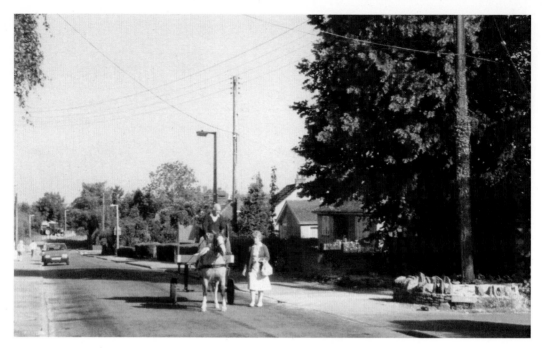

A pony and trap driven by Kenneth Britton stands in Beesmoor Road in 1989. Ken, of Park Lane, is speaking to Margaret Eaves, with the entrances to the old and new vicarages to the right. In the distance, a tractor comes out of a field which is now covered by the Park Farm estate.

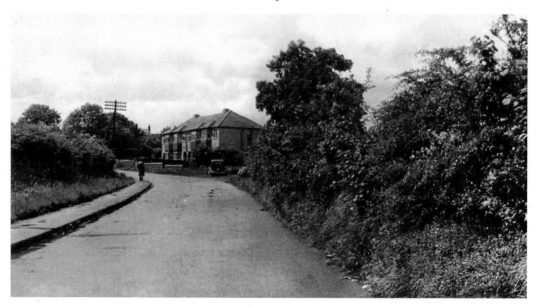

Numbers 158 to 164 Church Road. The change of name from Watermore Lane to Church Road was made in 1961 when road improvements were carried out. The terrace of four houses was a speculative development, completed just before the outbreak of war in September 1939. The builder was Wilfred Bryant, a local property developer, and the terrace may be rated as amongst the first modern housing locally, where there had been a virtual standstill in such work for twenty years.

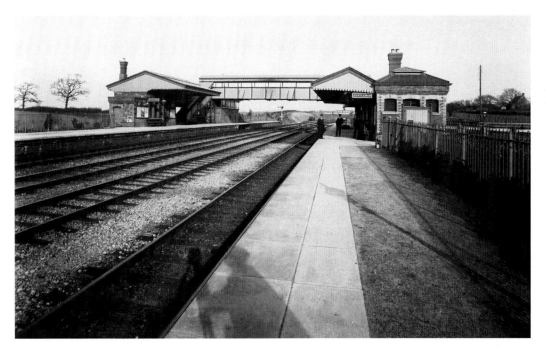

Coalpit Heath railway station, photographed around 1905 by Miss Dorothy Hewitt, whose shadow can be seen in the foreground. Railway staff, and a lady with what appears to be the Hewitts' dog, Spot, wait on the Down platform, where the station provided waiting accommodation, ladies' rooms and lavatories, and conveniences for men. On the Up passenger platform was a small brick-built waiting shelter and toilet. Coalpit Heath was the penultimate station on the Great Western Railway's 'Badminton Line', constructed between 1897 and 1903, which opened for goods and passenger traffic in 1903. The last passenger train left the station on 3 April 1961, the station closing the following Monday.

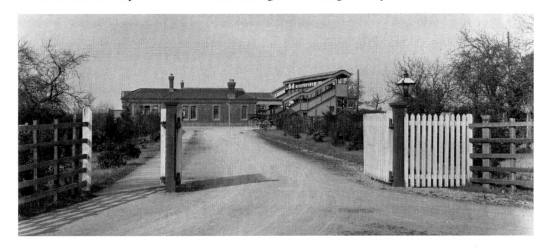

Access to Coalpit Heath station for both vehicles and pedestrians was from nearby Ram Hill, with the more appropriately named Station Road some distance away. The total cost of building the station amounted to £1,009 7s 7½d; the station building was £491 17s 7½d, the waiting shed was £172 10s, and the platform coverings were £272. A horse and carriage, which has probably conveyed Dorothy Hewitt and her camera equipment, wait by the main station building in this photograph, taken around 1905.

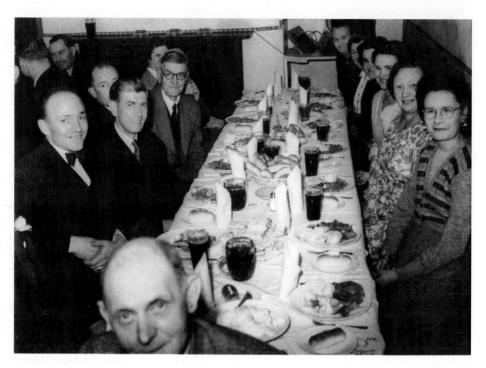

Guests enjoying a salmon supper evening held in the smoke room of the Star Inn, Watermore Lane. Ken Davis, who lived in Alexandra Road, cooked the 22lb fish in a large steamer for this one-off occasion in 1954. Seated on the left side of the table, from left to right: Jonah Scott, Joe Smith, Gilbert Dutfield, Samuel Stone, Mrs Fred Brown. On the right of the table: Mrs Alfred Nichols, Mary Drew, Doris Smith, Mrs Scott, Evelyn Davis, Mrs Raymond England. Herbie Dando is the gentleman in the foreground, with Frank Simmonds of Frog Lane Farm facing the camera in the corner.

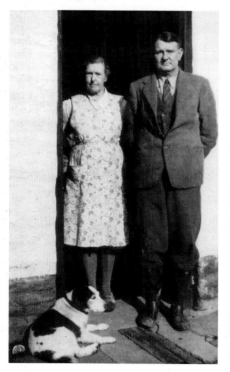

Albert and Emma Mitchell standing at the back door of the Star Inn in 1951, with their dog Patsy. The couple took over the running of the pub in 1929 on the death of Emma's father, Frederick Adams. Fred became landlord of the pub in 1911, taking over from his mother Emma who died that year, aged eighty-six. The family's association with the Star Inn started in the mid-nineteenth-century, with Thomas Adams and his wife Emma enumerated at the pub in the 1851 census. Over the next forty-odd years Thomas was employed as a coal miner and agricultural labourer, returning to the Star by 1891. Thomas died in 1895, leaving his widow Emma to run the pub with the help of her two sons Frederick and George.

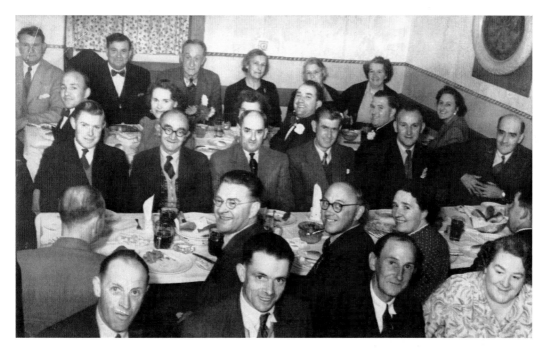

A turkey dinner at the Star Inn, Christmas 1956. From left to right, back row: Albert Mitchell (landlord of the Star Inn), Alfred Nichols, Jim England, Mrs Emma Mitchell, Alice Bird, Margaret Buckland. Third row: Jonah Scott, Mrs Rene Scott, Mrs England, Raymond England, Fred Woodruff, Mrs Daisy Woodruff. Second row: John Lawrence, Mr Morris (landlord of the Rising Sun), Mr England, Joe Smith, John Hacker, Royston Payne. First row: -?-, -?-, Mr Mildred, Mrs Mildred, Len Nelmes. Front row: Fred Crew, Albert Bisp, Lawrence Batten, Mrs Batten.

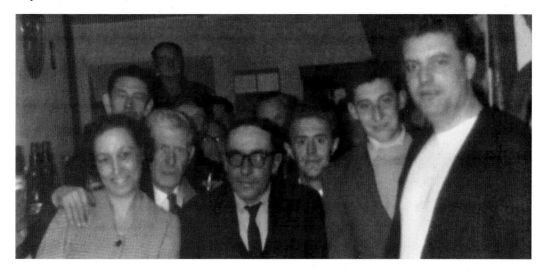

Albert Mitchell's last night as landlord of the Star Inn, October 1964. From left to right, front row: Jean Mitchell, Joe Smith, -?-, -?-, Jimmy Croft, Ben Iles. Standing behind Jean Mitchell is Mr Allen. Jean ran the pub for the last three years of Albert's tenancy due to his failing health. Mr and Mrs Young from Mangotsfield took over the pub, which had been supplied by Georges & Co., Bristol Brewery, and, from 1961, by Courage Brewery during the Mitchells' thirty-five-year occupation.

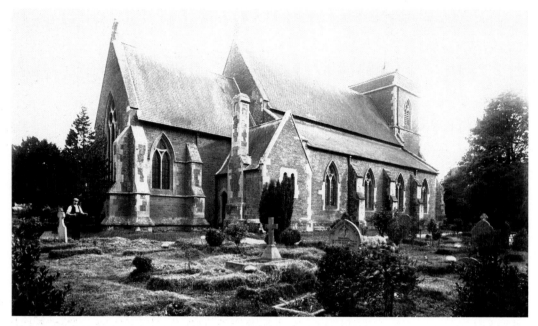

The original north-west elevation of St Saviour's Church, photographed in the early 1900s before the vestry was extended in 1908 to double its size. A fireplace and chimney were incorporated into the gable end of the extension. The grave mounds are well maintained, some with protective domes over the floral arrangements.

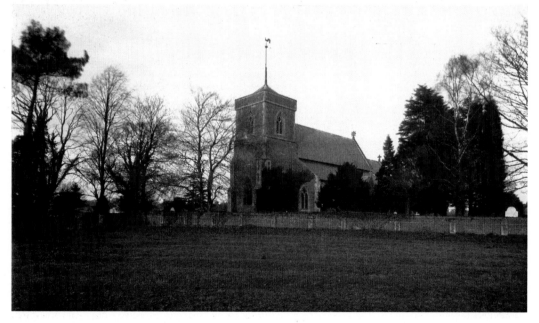

The south-east elevation of St Saviour's Church prior to the extension of the churchyard. The churchyard extension was gifted to the church by the Lords of the Manor of Westerleigh and dedicated on 17 December 1912. This picture predates the manufacture and installation of the church clock by John Smith & Sons, Midland Clockworks, in 1913.

Four generations of a Coalpit Heath family, *c.* 1915. From left to right, adults: Mary Ann Hacker (*née* Hallier), Ethel Louise Holbrook (*née* Tremlin), and Elizabeth Ann Tremlin (*née* Hacker). Children: Gwendoline May Holbrook and Leslie Hayman Holbrook. Mary Ann Hallier, born around 1835, was the daughter of John and Mary Hallier. She married Samuel Hacker in 1852. Their daughter, Elizabeth Ann Hacker, born in 1853, married Joseph Tremlin in Bristol in 1879. The Tremlins' eldest child, Ethel Louise Tremlin (1880-1941), married Albert Hayman Holbrook in 1906. Gwendoline May Holbrook, born 7 March 1907, married William Hutton in 1931 and became housekeeper to Dorothy Hewitt at Serridge House; her husband Bill was the gardener. The couple moved with Miss Hewitt when she left Coalpit Heath in 1947 for a new residence at Brentry. Gwen died on 24 March 2003; Leslie died in 1955, aged forty-four.

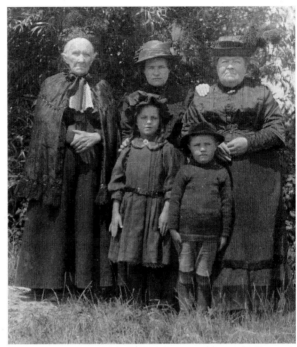

St Saviour's bell ringers, 1933. From left to right, back row: Revd Ernest J. Phillips, Gerald Smart, Raymond Williams, Donald Marsh. Middle row: Christopher Holbrook, Royston Payne, Albert Rodman, Leslie Francombe, Horace Benson, Claude Gifford. Front row: Charles Dando – the bell ringers' mascot. Mr Francombe, a long-standing member of the choir, ran a fruit and vegetable shop in Church Lane, near Coalpit Heath post office, for many years.

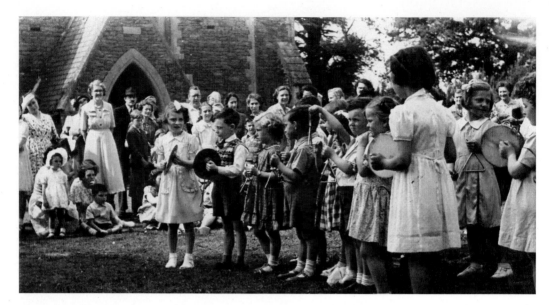

Attendees at St Saviour's Church garden party (held in the vicarage garden in 1951 or 1952) are entertained by the Manor School percussion band. Banging the cymbals are Angela Jenkins and Michael Tovey; playing the triangles, from left to right, are: Susan Boulton, Hugh Simmons, Glenys Williams, Robert Anstey, Valerie Singleton and Sheila May. Jacqueline James, far right, plays the tambourine. George Tovey is the gentleman in the trilby with Janet Brown, Mrs Williams, Mrs Moseley, Mrs Hanks, Mrs Henderson, Mrs Martin, Diane Simmonds and Mrs Vera Boulton also identified in the crowd of onlookers.

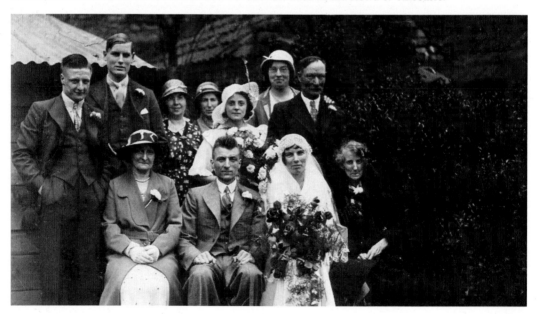

Gerald Walter D. Smart and Madeline Ruth Hunt (known as Ruth) pose at their wedding reception, 19 May 1934. Married at St Saviour's Church, the couple, both born in 1908, spent nearly sixty glorious years of wedded life together. Ruth died in 1993, aged eighty-five; Gerald died in 2006, in his ninety-eighth year. From left to right, back row: Cyril Smart, -?-, -?-, -?-, -?-, -?-, Mr Hunt. Front row: Mrs Edith Smart (1886-1972), Gerald Smart, Ruth Hunt, Mrs Hunt.

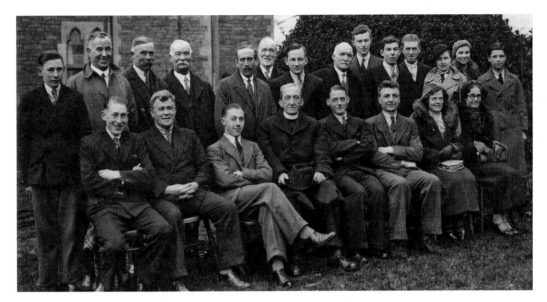

The Revd Phillips, vicar of St Saviour's between 1906 and 1936, with members of the church's Bible group, photographed in the 1930s. Gerald Smart is third from the right in the front row. Claude Gifford is seated to the vicar's right, with Mr Nelmes next to him. Horace Benson is between Revd Phillips and Gerald Smart. A young Christopher Holbrook is standing on the extreme left. Ernest John Phillips, born in 1875 in Bristol, the son of John and Alexandra Phillips, died in 1953 and is buried in St Saviour's churchyard. His spinster sister Alice Celia Phillips, who also lived at the vicarage, died in 1928 aged fifty-six.

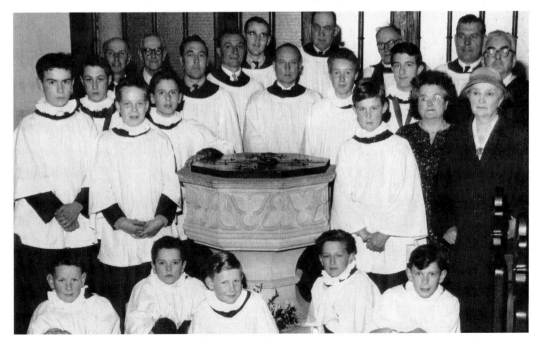

St Saviour's Church choir, 1962. From left to right, back row: Cyril Batten, -?-, Trevor Gifford, Gerald Smart, -?-, -?-, Revd Kingsley Martin, Raymond Williams. Middle row: -?-, David Gifford, -?-, -?-, -?-, -?-, -?-, Paul Chaplin, Derek Tovey, -?-, Mrs Ramsey. Front row: -?-, -?-, Christopher Holbrook, -?-, -?-.

A group of local gentlemen gathered at Mayshill on Sunday, 2 May 1937, who all signed the reverse of the photograph that belonged to George Bennett of Say's Court Farm. Christopher Shepherd (farmer, Mayshill), John Park Eley (Chestnut Farm, Mayshill), Geo. H. Young, Robert Wilson, E.A. Young, D. Smith (away in Paris at the time of the photograph), George H. Bennett (Say's Court Farm), ?.J. Coombes, M? Collett, Arthur T. Fox, C.?. Waters, David ?, J.B. Kendall?, Mark W. Crossman?, and one unidentified signature.

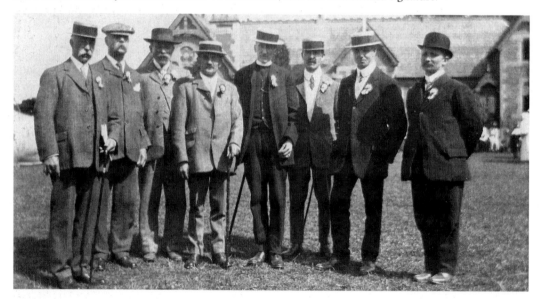

Members of the Coronation Celebration Organising Committee display their badge of office and wear the appropriate headgear. From left to right: George Colthurst Hewitt, -?-, -?-, -?-, Revd Ernest Phillips, -?-, -?-, -?-. The Coronation of King George V on 22 June 1911 was celebrated at Coalpit Heath in some style on the following Tuesday, 27 June, as reported in the *Bristol Times and Mirror*: 'The arrangements were made by a large and representative committee with the Revd E.J. Phillips (vicar of St Saviour's) as chairman and Mr W. Newman as his secretary and treasurer.'

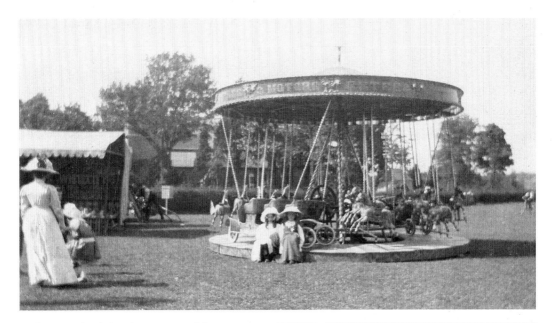

A photograph of the Coronation celebrations
held on the Manor School playing fields,
27 June 1911. In glorious weather, two children
pose in front of the hand-cranked 'Galloping
Horses' carousel with St Saviour's Church in the
background. A large marquee was erected on the
field, and amongst the attractions was Rogers'
Penalty-Kick challenge.

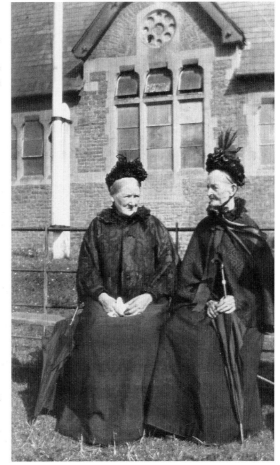

Two ladies of distinction sitting against the
Manor School railings, each lady complete
with bonnet, cape and parasol. The photograph
was taken on Tuesday, 27 June 1911, at the
celebration of the Coronation of King George V,
at the recreation ground adjoining the
Manor School.

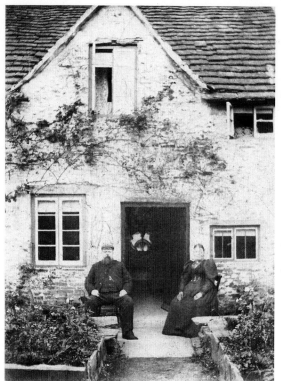

John Albert and Eliza Cook sitting outside their home, Walnut Cottage, Coalpit Heath, *c.* 1890. John, born 5 March 1845, the son of John and Hannah Cook, was a coal miner at Frog Lane Colliery and in the 1861 census is described as 'Constable at coal mine'. He died in March 1921. Eliza (*née* Woodruff) was born 26 November 1842. Their only son, Ethelbert, was also employed at the colliery, starting as a stoker on steam locomotives and progressing to driving the railway engines. Bert (as he was known) and his wife Eliza Ann (*née* Savage) also lived in the cottage for a period, following their marriage in April 1905. Although named Walnut Cottage, the building (now demolished) is quite substantial judging by the gable at the front of the property and the size of the front door.

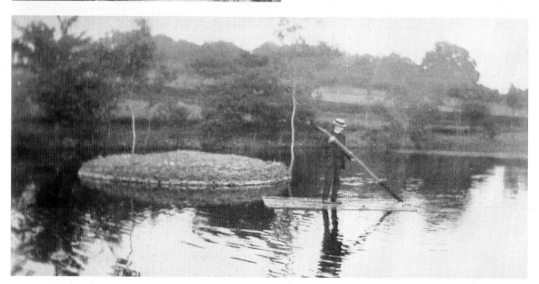

The intrepid vicar! The Revd Ernest John Phillips punting across a reservoir pond, known locally as 'The Clamp', on what appears to be an old door, confident in his ability and skill gained from his days at Pembroke College, Oxford. 'The Clamp', located in Henfield Road, between Serridge House and Kendleshire Golf Club, was associated with the local mines, with the overflow from Bitterwell Lake going into the man-made pond. The Revd Phillips MA, vicar of St Saviour's from 1 June 1906 to 1936, was Rural Dean of Bitton from 1927 and Hon. Cannon of Bristol Cathedral from 1930. Upon his death in 1951, he was returned to St Saviour's to be buried with his wife, occupying the first grave in what was the new extended churchyard.

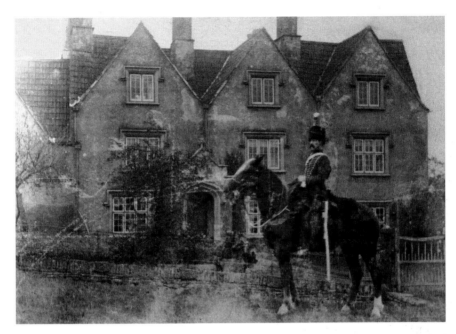

Corporal George Henry Bennett (1873-1966) of the Royal Gloucestershire Hussars photographed in front of Say's Court Farm around 1900. George's father, Stephen from Staple Hill, began farming at Say's Court during the 1890s, with George taking over the farm at the start of the twentieth century. Members of the Bennett family still live in the property.

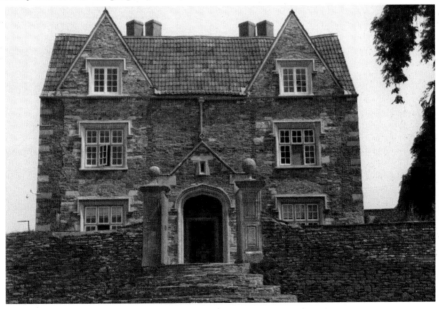

The south elevation and entrance porch of Say's Court, with the stone spheres on top of the gateposts reputed to signify that the house was the residence of a Justice of the Peace. Originally this was the main entrance to the house, at the end of a long private drive from Frog Lane. The principal entrance had to be changed to its current location, on the west elevation, due to the opening of Frog Lane Colliery in the 1850s, requiring a new private road with a bridge over the railway branch line to Mayshill and Nibley collieries.

The Homestead, Badminton Road, was built in 1931 by the son of Samuel Stone, one-time licensee of the Half Moon Inn. Frederick G. Stone of the Homestead had spent some time in the United States and the name of the 'American House', accorded to the property by local inhabitants, was appropriate in view of the railed one-storey extension, a very New England building style. Fred died in 1935, aged sixty-six. The property was demolished in the 1960s to make room for Hartwell's car sales showroom and repair workshop. A modern housing development, Homestead Close, now occupies the site.

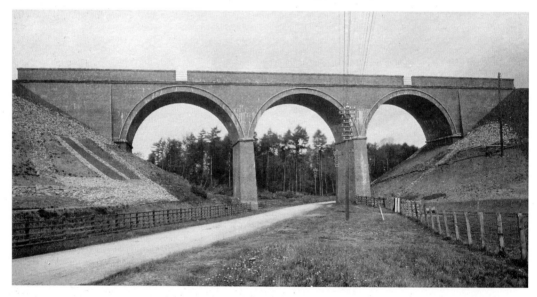

The newly completed bridge for the Great Western Railway's 'Badminton Line', constructed between 1897 and 1903, spans a relatively quiet Badminton Road in 1902 compared to today's busy thoroughfare. Changes were made to the original viaduct proposals as work progressed, and an embankment and a three-arch bridge were substituted for the eight-arch viaduct originally intended. This was due to the various underground coal workings in the area, which gave rise to fears that the ground surface would be too unstable to take the weight of the supporting piers. Blackberry Brake is the wooded area in the distance.

3

EVENTS AND PEOPLE

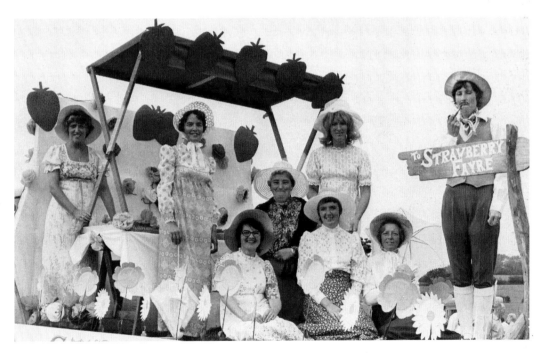

The Coalpit Heath Young Wives tableau at the Frampton Cotterell Carnival, September 1975. An annual event for many years, the carnival procession at this time commenced at Crossbow House and ended in Mr Alfred Nichol's field, opposite the Star Inn, Church Road. From left to right, standing: Jacqueline Britton, Mary Tomkies, -?-, Maureen Thompson. Kneeling: Pauline Gearing, Sheila Isaacs, Barbara Chard, Margaret Underhill.

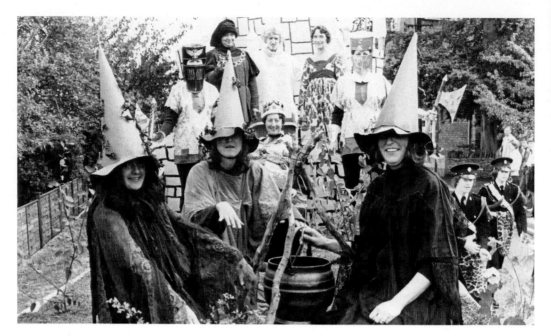

Witches around the cauldron: the Coalpit Heath Young Wives *Macbeth* tableau during the Frampton Cotterell Carnival procession on Saturday, 11 September 1976. From left to right, back row: -?-, Joy Banks, Jacqueline Britton, Mary Tomkies, -?-. Middle: Sheila Belcher. Front row: Pauline Gearing, Sue Weaver, Maureen Thompson. The Downend Church Lads Brigade band provided the music for the parade.

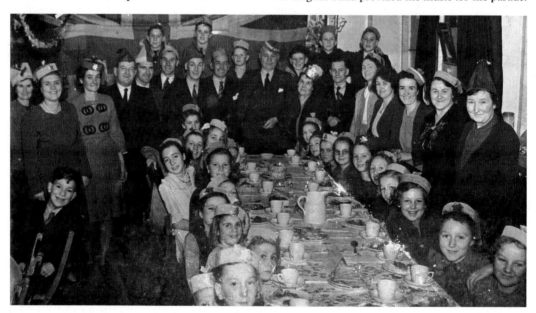

A 1947 party at the Manor School, for children of Frog Lane miners. Norman Turner is the boy sat on the chair on the left of the picture. Girls seated on the right of the table, from left to right: -?-, -?-, Primrose Thornell, Norma Davis, Susan Williams, -?-, Jean Langley, Betty Teagle, Myrtle Tovey, Marie Nicholls. Mary Sheppard is the girl in white leaning out in the middle. Mrs Ida Dee is standing second from the left; Randolph Tovey is fifth from the left, with Henry Langley to his left.

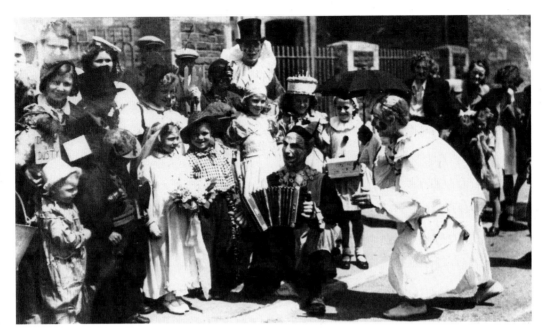

In the 1930s, the Frampton Cotterell and District Horticultural Society held an annual charity show in August, when adults in fancy dress made collections for worthy causes such as the Bristol Royal Infirmary. The show also included a fancy-dress competition for the children of the area, who are pictured here outside the Council School in Woodend Road.

A VE Day party gathered outside the Salvation Army hall in Clyde Road in 1945. The Salvation Army began its work in Frampton Cotterell in 1882 and remained in the same premises until 1957. After a period of dereliction following the closure of the Salvation Army, the hall was converted into two shops: a television sales and repair shop for Leeson-Magrey and a chemist's shop for Mr Peter Cook, who later moved to Lower Stone Close. The Revd Charles Wood, vicar of St Peter's Church, is the gentleman wearing spectacles seated in the front row, with Hazel Williams to his left. Ernie Woodruff is in the sailor's uniform. Vera Boulton, Cynthia Boulton and Mrs Milsom are also in the picture.

The Silver Jubilee of Elizabeth II marked the twenty-fifth anniversary of Queen Elizabeth's accession to the throne and was celebrated with large-scale parties and parades throughout the UK. On 7 June 1977, the streets and villages threw elaborate parties for all their residents, like this one in Park Avenue. Tony Nelmes helps serve food to the children, who were all presented with a commemorative mug.

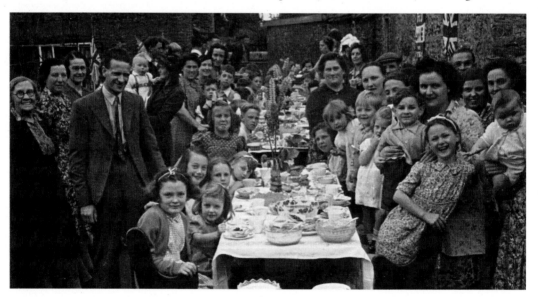

One of a multitude of VE Day parties that took place throughout the country in May 1945 to celebrate the end of the Second World War in Europe. This one is for the residents of The Ridge, Coalpit Heath. The adults on the left of the picture are, from left to right: Mrs Woodruff, -?-, Mrs Short (from the Horseshoe pub), Mr Lloyd, Mrs Tovey (holding the baby), Nellie May Drew, Mary Drew, -?-.

Mrs Cook, Iris Smart, Mrs Varlow and May Dutfield are in the group of adults on the right of the picture. Pamela Claydon is sat at the front of the table on the left, with Ivy Green and Joy Cook behind her.

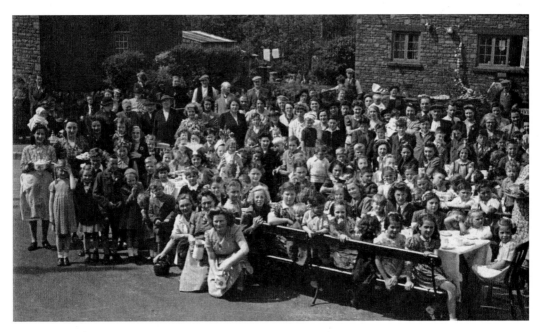

Another VE Day street party, this one held at the junction of South View and Woodend Road, Frampton Cotterell, in front of No. 178 Woodend Road. Dorothy Luton is the lady, centre front, holding a jug. On Friday 4 May, German forces in north-west Europe surrendered to Montgomery's HQ on Lüneburg Heath. Three days later, on Monday 7 May, the German supreme command surrendered at Rheims in France.

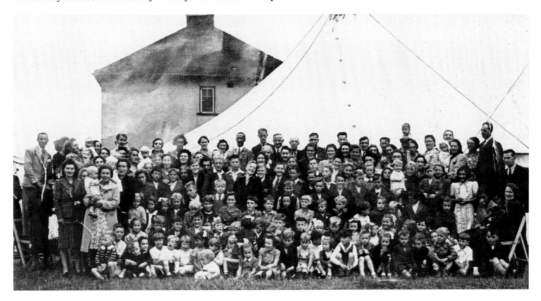

A VJ (Victory in Japan) 'Park Laners' party for the residents of Park Avenue, Nightingale Close, Frome View and Park Lane. A marquee was erected in Charlie Skidmore's garden for the August 1945 celebrations. People identified in the photograph are: Joe Cake, Mrs Cake, Nora Wilson, Mrs Skidmore, Lucy Pearce, Mrs Mustoy, Mrs Mainstone, Ken Hobbs, Mrs Coles, Ronald Coles, Charlie Skidmore, John Taylor, Mrs Hobbs, James Hawkins, Gordon Tanner, Melvyn Bowyer, Anne Edwards, Clive Skidmore, Diane Tovey, Dinah Hodge, Joan Tovey with baby, Clive and Joan Lewis standing next to each other, Mr Gale and Joan Gale, John and Paul Hacker, and Alfie Matthews.

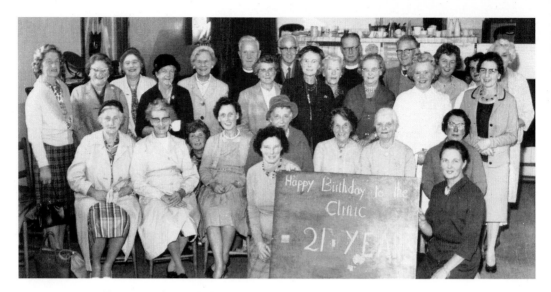

Frampton Cotterell Baby Clinic was held on the first Wednesday of each month in Wesley Chapel hall. Joining in the twenty-first birthday celebrations of the clinic are ladies, past and present, who helped run the clinic by weighing the babies and providing refreshments for the mums. From left to right, back row: Mrs Bennett, Mrs Amy Teagle, Rene Cane, Mrs Sumner, -?-, Revd Joseph Law (minister of Wesley Chapel), Mrs Law, Charles Passmore, Gwen Passmore, -?-, Revd Charles Wood (vicar of St Peter's), -?-, -?-, Mrs Daniels (health visitor), -?-, -?-, -?-, -?-. Front row: Mrs George Wright, Mrs Smith, -?-, Mrs French, Mrs Wood (vicar's wife), -?-, Miss French, -?-. Holding board: Ruth Smart and -?-.

A Coalpit Heath flower show sometime in the 1980s. From left to right, back row: -?-, Doris Lear, Kate Player, Nora Jackson. Middle row: Constance 'Connie' Holbrook, -?-, Mrs Smith, Mrs Ida Dee, -?-, -?-. Front row: -?-, Mrs Miles, Horace Benson, -?-, Mr Miles, Charles Milsom.

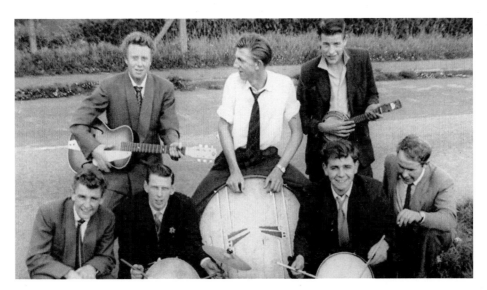

In the early 1950s, Coalpit Heath boasted its own rock band under the leadership of 'Slim' (Tony) Hendy. Photographed outside the Lord Nelson pub on the road to Weston-super-Mare, the band members are, from left to right, back row: George Griffin (guitar), Slim Hendy (drums), Barry Tremlin (banjo). Front row: Dave Lanford (guitar), Denis Eastman (vocalist), John Cornock (harmonica), Frank Thornell (guitar). Originally named The Toffs and later The Saints, over the years personnel changed as much as the name; it was not until the band was playing at The Glen, Durdham Down, in the late 1960s that the name Chantilly Lace came into being and remains to this day.

A Renown Radio coach, parked outside the New Inn at Mayshill, waits to transport a party of Mayshill residents to Severn Beach for a half-day outing to celebrate VE Day 1945. Standing in the coach, from left to right: -?-, Myrtle Gardiner, -?-. Back row: Godfrey Gardiner, Mr Edwin Gardiner, Mrs Adelaide Gardiner, Betty Curtis, Evelyn Davis, Peter Davis, Ken Davis, Mr Marsh. Middle row: David Dee, Lizzie Wilcox, Annis Wilcox, Ken Clark, Bill Curtis, -?-, Mrs Curtis, Lilian Cook, Mrs Ida Dee, Mrs Clark, Mrs Parsons, Mr Parsons. Front row: Douglas Glastonbury, Colin Dee, Phyllis Curtis, Nina Curtis, Sylvia Cook, Colin Davis, Austin Copestake, -?-, Stuart Wilcox, Michael Davis.

Fred Tovey, on his bicycle, hitches a ride at the side of Gilbert Gale's children-laden coal lorry as the Frampton Cotterell Carnival procession passes the Horseshoe pub in The Causeway in April 1948. Competitors in the children's fancy-dress competition follow behind on what appears to be a rainy day. In the lorry are David Holway, Rodney Axford, John Mainstone, John Nelson and Christine Lewis. Bonnie Wilcox is the first female in the following procession.

During the Second World War, women and girls were encouraged to help the war effort and support the troops by knitting socks for soldiers. This group of girls from Frampton Cotterell Council School, pictured in the school playground, proudly display a number of completed pairs. From left to right, back row: Joan Lewis, Ella Nicholls, Jean Mitchell, Edith Williams, Phyllis Tovey. Front row: Audrey Woodey, Cynthia Thomas, Doreen Cordy, Joan Thomas, Winnie Alden, Maureen Biggs.

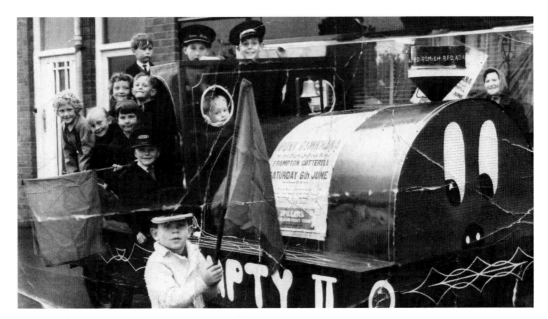

The Humpty Train was the work of five men – Bob Drew, Roy Pitt, Ben Courage, Dennis Jones and Ian Milne – and was created from a Ford 8 van donated by Ron Morris; the Pullman carriage was the rear end of a Bedford van, donated by Brookman's bakery. It was built in 1965 and for fifteen years toured the local village fêtes and shows, giving pleasure rides to children. The train was withdrawn from service as a result of a less relaxed interpretation of road tax, insurance and safety matters by the authorities! In this photograph, David Pitt waves 'full steam' for Humpty II, outside Collette's hairdressers in Lower Stone Close, whilst Beverly Curtis dons the stationmaster's hat in the centre.

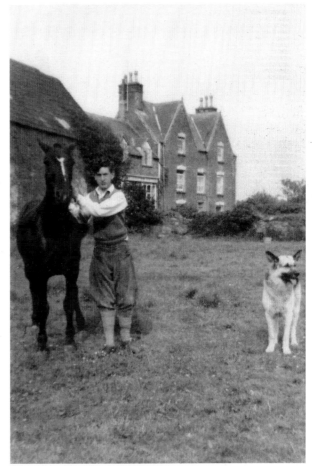

A youthful Alan Jenkins (1939-2010), photographed in 1957, with his young horse Lancer and dog Max. The substantial house behind him is Brookman's bakery, formerly Parsonage Farm. The building attached to the main house is the radio, television and electrical shop which was owned by Alan's father, Ernest V. Jenkins, from 1952 to 1968. The land is now occupied by Nos 450 and 452 Church Road.

George Boulton, from Long Newnton, Wiltshire, the son of Henry and Margaret Boulton, married Rosina Elizabeth Witchell of Frampton Cotterell in 1912, whilst stationed at Kingswood as a member of the Gloucestershire Constabulary. During the First World War, George joined the 129th (Bristol) Heavy Battery, Royal Garrison Artillery. On 2 February 1917, he was admitted to No. 14 General Hospital at Wimereux, a coastal town situated some 3 miles north of Boulogne, with a severe fracture of the right tibia. Repatriated to the UK, Gunner 145 George Boulton died on 21 February 1917, aged thirty-two, and is buried in Tetbury Hill Cemetery, Malmesbury.

Rosina Elizabeth Boulton (*née* Witchell) with her two children: Hilda (born 1913) and George (born 1915). Rosina, the eldest daughter of coal miner John Witchell and his wife Laura Elizabeth (*née* Green), was born in Frampton Cotterell in 1888. The Witchell family lived next door to Laura's parents, John Tanner Green and Elizabeth, in Upper Stone Close. Widowed at the age of twenty-six, after the death of her husband George in the First World War, Rosina never remarried and died in 1983.

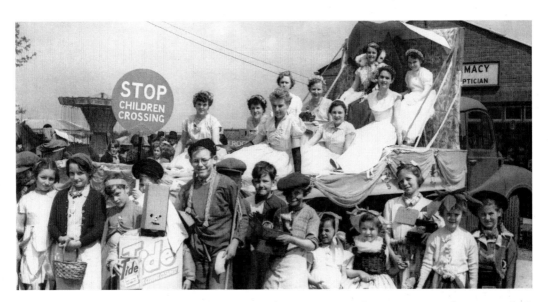

In the 1950s, the Frampton Cotterell Carnival was an annual event held in Beesmoor Road recreation field. Local young ladies sold programmes for the carnival; the one who sold the most became Carnival Queen and those who sold lesser numbers were her attendants. From left to right: Wendy Cook, Mary Teagle, Marie Nicholls, Valerie Hanks, Jean Langley, -?-, -?-, Margaret Fry, Yvonne Batten. Children, from left to right: Rosemary Leonard, June Iles, -?-, -?-, -?-, Gerald Wren, -?-, Rodney Axford, Carol Stuart, -?-, Angela Curtis, Judith Cox, -?-, Ann Oxenham. The carnival procession started in Lower Stone Close and continued through the village to Beesmoor Road. Rogers' fairground, in the background, is in the field that was to become the site of Highcroft School. The building behind the float is Stone Close Pharmacy, run by Thomas Jacobs.

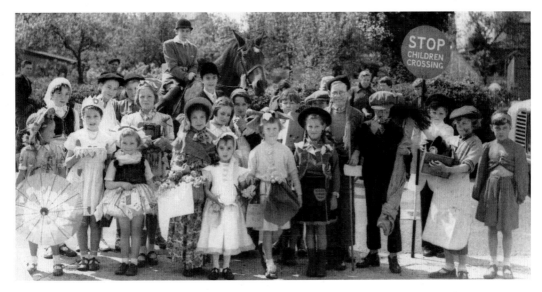

A popular regular feature of the carnival was the fancy-dress parade and competition for children of the area, some of whom are lined up for this photograph taken in Lower Stone Close. Judith Cox, Angela Curtis, Margaret Wilding, Beryl Jenkins, Christine Lewis, Rosemary Leonard, June Iles, Rodney Axford, Ann Oxenham, Carol Stuart, Gerald Wren and Malcolm Lewis are among the participants.

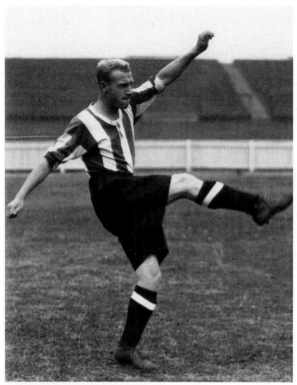

Ronald Clarence George Green, born 12 March 1912 at Frampton Cotterell, son of Alfred George Green and Alice Green (*née* Smart). Ron Green was a regular in the Bath City reserves side during the 1931/32 season, and then helped Bristol Rovers equal their best-ever League position of ninth in Division 3 (South) in the 1932/33 season. Transferred to Arsenal, he helped the Gunners' reserves towards two consecutive London Combination titles. His three goals in five London FA Challenge Cup matches included two in a 4-0 victory over Spurs in the 1934 final. After making sixty-three appearances (scoring thirty-three goals) in the London Combination, he moved on to Notts County before the end of the 1934/35 season, where he played thirty-six games for the Meadow Lane club. He enjoyed a brief spell with Charlton Athletic, and eight League games for Swansea Town, before his retirement from professional football.

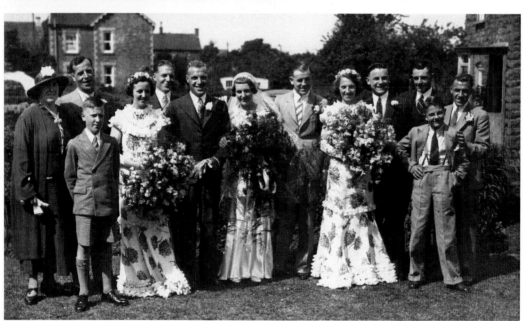

Ronald Green married Violet M. Blake at St Saviour's Church in 1937. The wedding reception was held at his parents' home, No. 14 Upper Stone Close, where this group photograph was taken. From left to right: Alice Green (*née* Smart), Alfred George Green, Harold Reginald Green, -?-, Alfred Frank Green, Ronald Green, Violet Blake, -?-, Marion Kathleen Green, -?-, -?-, -?-, Herbert John Green.

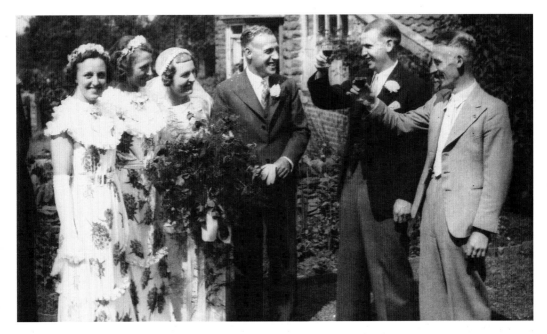

Ron's best man at his wedding was one of the most famous footballers of the time. Cliff Bastin (wearing the dark jacket, toasting the bride and groom) registered 178 goals in almost 400 games for Arsenal, and formed an integral part of the side that dominated English football in the 1930s. He was capped for England on twenty-one occasions.

Harry Green (1911-1987) from Illinois, his wife Molly, and their daughters stand in front of a plaque on the wall of No. 72 Frampton End Road. The plaque commemorates the fact that in the nineteenth century, Harry's grandfather's family occupied a cottage on the site. Harry's father, William R. Green (1870-1911), born in a log cabin in Ohio, became a state senator, trade union leader and president of the American Federation of Labor from 1924 to 1952. Bill Green's parents, Hugh and Jane Green, together with Hugh's brother Joseph, emigrated in 1869 and, immediately upon reaching the United States, made their way to eastern Ohio and the mining and farming town of Coshocton. Hugh (born 1838) and Joseph (born 1843), both coal miners at Coalpit Heath, were sons of Joseph, a road labourer, and Margaret Green, who lived in the cottage in Frampton End for over forty years.

Frampton Cotterell Council School Parent Teacher Association, photographed in the 1950s. From left to right, back row: Alan Bryant, Edgar Lewis, Reg French, Gilbert Dutfield, John Cook, Roger Lewis, Maureen Dutfield, Jill Dutfield, Zena Dutfield, Mrs Taylor, -?-, -?-. Second row: Winifred Dando, Eileen French, Kate Anstey, Gilbert Buston, Harold Fry, Ivor Skidmore, Horace Drew. First row: Margaret Fry, Miss Evans (teacher), Mrs Rue, Mrs Bernice Cook, Revd Charles Wood, Phyllis Buston, -?-, Clarice Wilcox, Thelma Bryant, Mrs Drew, Eileen Cook, -?-, Jim Holway, -?-, Edith Lewis, Mrs Mainstone, -?-, Mrs Dutfield, Mrs Fry, Mrs Nelmes, Mrs Ramsey, Mrs Gardiner, Irvin Robbins, -?-, Mollie Holway (school secretary). Front row: Miss Goddard (teacher), Rosemary Hickling, Christine Lewis, -?-, Mrs Wood, Mr Evans (headmaster), Mrs Evans, Mrs Watkins.

One of the tableaux participating in the 1953 Frampton Cotterell pageant, organised by Irvin Robbins, in the Royal British Legion Memorial Hall. From left to right, back row: Margaret Loosley, Maureen Elson, Marie Nicholls, Shirley Lowe, Margaret Reed. Front row: Rosemary Hickling, Nora Hickling, Margaret Baldwin, Valerie Lear, Sonia May.

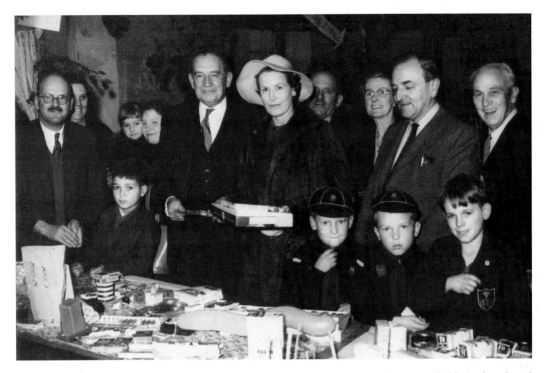

The Autumn Fayre, a sale to raise funds for Zion Chapel, was a regular event held in the chapel schoolroom. This one is taking place around 1964. Adults from left to right: Mr W. Woods (deacon of the chapel), -?-, Major Haywood, Mrs Haywood, Mr Rathbone, Gwen Passmore, Cyril Minns, Charles Passmore. Mr and Mrs Passmore were joint lay pastors at Zion from 1944 to 1964.

Coalpit Heath Women's Institute won first prize in the annual Frampton Cotterell Carnival in 1975 with their tableau 'The Hunt'. From left to right: Doris Vowles, Alison Maine, Joan Maine, Ann Fluck, Maureen Youell, Nan Matthews.

Mr Carthew's Frampton Cotterell Council School class of 1953, pictured in the school grounds (where the Brockeridge Centre now stands). From left to right, back row: Pauline Cake, Carol Willett, Margaret Eaves, Janet Elson, Pauline Smith, Jennifer Hickling, -?-, Dorothy Tovey, -?-, Coral Smith. Front row: Sylvia Winkworth, Jean Lewis, Josephine House, Kathleen Lewis, -?-, Sylvia House, Jean Pointing, Margaret Adams, Esme Lewis, Ann Russell?, Rosemary Leonard, Pamela Smith, -?-.

A Frampton Cotterell Council School class photograph, *c.* 1949. From left to right, back row: Royston Tremlin, Bryan Lear, Roger Lewis. Middle row: Mr Roberts (headmaster), Raymond Woodey, Michael Greenaway, John Hacker, John Lewis, Clive Luton, Mr Garmston. Front row: James Hawkins, Raymond Stowe, Dennis Drew, Raymond Salmon, John Curnock.

Frampton Cotterell Carnival Queen, Norma Tovey, and her attendants are transported up Woodend Road on 24 May 1952 en route to Beesmoor Road playing field for her crowning ceremony. From left to right: Christine Morris, Norma Tovey, Laura Taylor, Shirley Lowe, Phyllis Luton, Margaret Loosley. Note the fine example of drystone walling on what is now No. 110 Woodend Road.

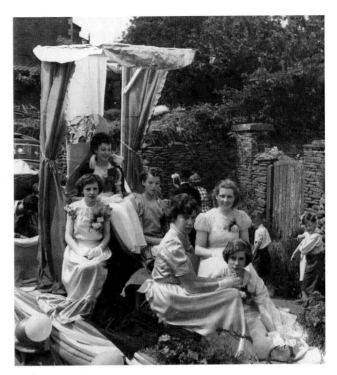

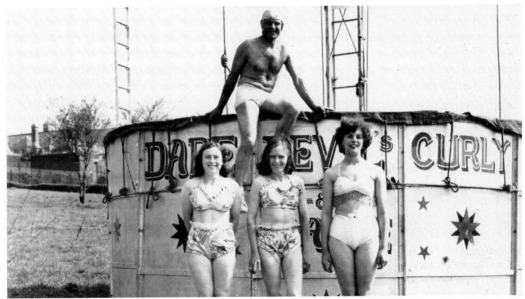

An attraction at the 1952 Frampton Cotterell Carnival was Dare Devil Curly, a showman who dived from a 72ft ladder into a tank holding 6ft of water, which had petrol poured on top and set alight. 'Curly', real name William Leyland, is pictured on top of the water tank with, from left to right, his wife Eloise, mother Madge, and Frampton Carnival Queen Norma Tovey. Eloise and Madge were trapeze artistes and a trapeze was rigged to the ladder from where they performed. 'Curly' did seasons with all the major circuses (including Billy Smart and Bertram Mills) and worked in carnivals and fêtes across the country, travelling and living in a converted single-decker bus.

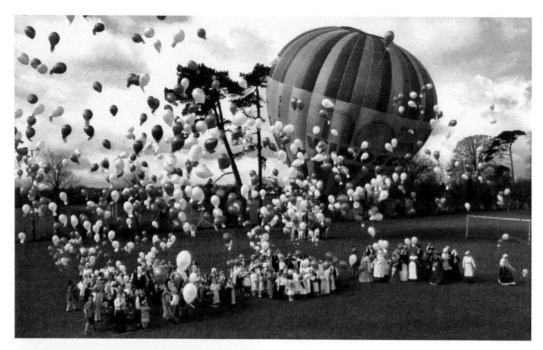

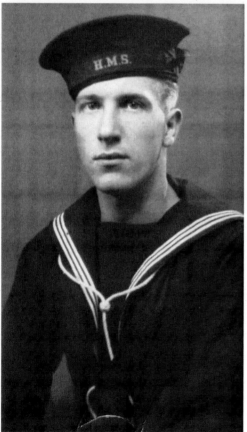

The release of balloons from The Park playing field was part of the celebrations to commemorate the 150th anniversary of the opening, in 1843, of the original Church of England or British School in School Road, Frampton Cotterell. Staff and pupils from the current school in Rectory Road dressed in Victorian costume for the day as part of the 1993 celebrations.

Harold Reginald Dennis Green, LT/JX 405478 Ordinary Telegraphist, Royal Naval Patrol Service, HM trawler *Birdlip*, died 13 June 1944, aged twenty. On the morning of D-Day, 6 June 1944, three trawlers, HMS *Birdlip*, *Inkpen* and *Turcoman*, sailed out of Freetown harbour towards the port of Grand Bassam in order to escort merchant ships along the coast. About midnight on 13 June, U-547 (commanded by Heinrich Niemeyer) fired a torpedo spread at the convoy, which struck both the *Birdlip* and the merchant ship *Saint Basile*. HMS *Birdlip* sank, with the loss of thirty-six crew members.

Harold, the son of Alfred George and Alice Green, of Upper Stone Close, is commemorated on the Lowestoft Naval Memorial and the war memorial in St Saviour's churchyard. His uncle, Herbert John Green, died 17 September 1918 whilst on active service with the 8th Battalion, Royal Berkshire Regiment.

4

THE HEWITT
COLLECTION

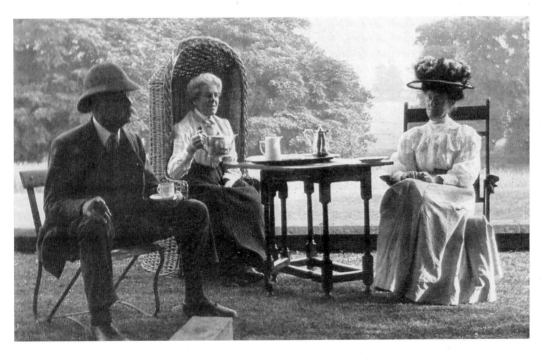

Edwardian aristocratic grandeur, reminiscent of the British Raj in India, as a trio take afternoon tea on the front terrace of Serridge House, Henfield Road, Coalpit Heath. The gentleman on the left is Mr George Colthurst Hewitt (1850-1913); the two ladies have not been identified. George Hewitt was a church warden at St Saviour's between 1882 and 1894. He died 19 March 1913 at Smedley's Hydro, a hydropathic spa and hotel at Matlock Bath, Derbyshire.

THE HEWITT COLLECTION

The photographs that have come to be known as the Hewitt Collection were rescued from obscurity as a result of an appeal by Steve Grudgings, the then chairman of the South Gloucestershire Mines Research Group (SGMRG). He wanted memorabilia and artefacts for an exhibition commemorating the sixtieth anniversary of the closure of Frog Lane Colliery. His appeal in 2009, broadcast by Radio Bristol, was heard by Anne Matson of Kingswood, Bristol, who was in possession of framed photographs, pictures, albums and glass plates, which included a number of mining photographs. Wondering if they might be of Frog Lane pit, Anne contacted the SGMRG. It emerged that Mrs Matson's aunt and uncle had been housekeeper and gardener to Miss Dorothy Hewitt at Serridge House, Henfield Road, Coalpit Heath until it was sold in 1948. The couple had continued in her service at her new home in Rose Acre, Charlton Lane, Brentry, living in a bungalow in the grounds of the house. Dorothy Hewitt died in March 1973, and, on the death of her erstwhile housekeeper Gwendoline Hutton in 2003, the images, many taken by Dorothy, were rescued from a shed in that garden by Anne and her husband.

The collection consists of over 300 photographs taken in the early years of the twentieth century on a variety of subjects. In addition to family pictures there are holiday photographs, still life, sea and landscapes, local scenes, the family home, as well as a set of Frog Lane Colliery – a number of which were taken underground alongside Cornishman John Charles Burrows, the pioneer of underground mining photography. Dorothy Hewitt was an amateur photographer of some repute, exhibiting her work at the Royal Photographic Society, Birmingham, the Bristol Photographic Club (1906-1907), and Southsea, Southampton and Hove exhibitions.

The Hewitt family originated from Wherstead, Suffolk and were for some 120 years prominent in the affairs of Coalpit Heath, in particular the Coalpit Heath Coal Co. In 1821, William Hewitt and his wife Elizabeth were residing at No. 8 Mills Place, Milk Street, Bristol, with William established as a coal merchant at Welch Wharf, Queens Street. In 1826 William was bookkeeper of the Coalpit Heath Colliery Co., and in 1841 was recorded as the mining agent for the owners of the Coalpit Heath Coal Co. William was one of the principal campaigners for the establishment of St Saviour's Church, and was one of its first church wardens. He remained with his wife and family at Heath Cottage, Coalpit Heath, until his death in 1856. William and Elizabeth had seven children. Henry Hewitt, their third child, married Sarah Colthurst in 1837 and is enumerated at Serridge in the 1841 census as a farmer with 150 acres. He is also listed as assistant manager of the coal works, which at that time comprised eight pits. Henry and Sarah also had seven children and it is from William Henry, their youngest, that Dorothy, the photographer, is descended. On 3 May 1878, William's wife Florence (*née* Fielder) died aged thirty-one giving birth to Dorothy Gertrude Hewitt.

Dorothy spent her early years at Serridge House, before being privately educated at a ladies' school in Abergavenny. At the completion of her education, Dorothy spent a period with her father's sister Mary Colthurst at Walton-in-Gordano, before returning to Serridge House in the early 1900s. Nationalisation of the coal industry took place in 1947, whereupon the Coalpit Heath Coal Co. was taken into public ownership and its non-mining assets, one of which was Serridge House, were disposed of at auction.

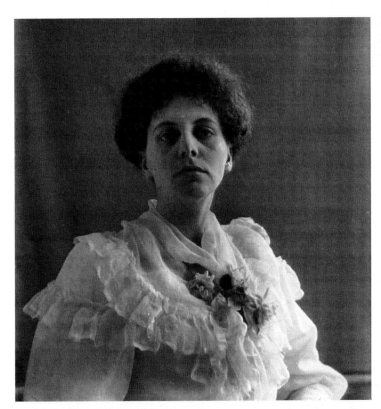

Dorothy Hewitt (1878-1973) photographed around 1906. Possibly a self portrait.

The gated entrance to Serridge House, photographed from Henfield Road, *c.* 1905. Ruffet Road passes the front of the gate, with Henfield Road to the left, just out of the picture. The Serridge estate, formerly part of Pucklechurch Park, was alienated (sold) separately from the Manor of Westerleigh by Sir Nicholas Poyntz, of Iron Acton Court, to Sir Maurice Dennis (Dennys) on 10 October 1574.

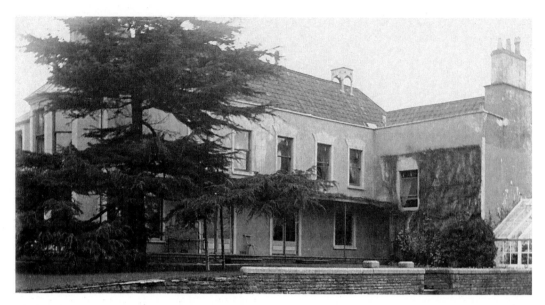

A view of the front of Serridge House, its veranda and terrace, with a strange cupola-type structure on the apex of the roof. The vine-covered wall is the oldest part of the house, thought to be constructed around 1600. In 1746, Sir Jarrett Smith and Lord Middleton, two of three joint Lords of the Manor of Westerleigh, purchased the mineral rights to the Serridge estate. However, the mineral rights, although allowing access over the land, did not include ownership of it – until 1786, when Mr William Clark sold the land of Serridge estate to the Lords of Westerleigh.

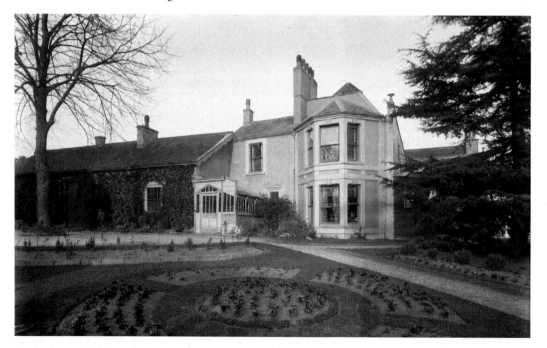

The well-maintained geometric-patterned flower garden of Serridge House. The entrance drive and forecourt are on the left of the photograph. The two-storey bay window is a prominent feature, as is the ornate conservatory and entrance door.

An autographed letter from Dorothy Hewitt, originally written on two sides of a headed card, dated 6 December 1941. The letter is addressed to 'Joffre' and was enclosed in an envelope with a monetary gift. 'Joffre' was Dorothy's name for William Hutton, the husband of Gwendoline, her housekeeper and maid. When Serridge House was sold, Mr and Mrs Hutton moved into a new bungalow built within the orchard of Rose Acre, the new home of Miss Hewitt.

December 6. 1941

SERRIDGE HOUSE,
COALPIT HEATH,
NR. BRISTOL.

Dear Joffre

Will you accept the enclosed with every good wish. I thought you would rather have it in this form than a wedding present.

May you and your bride have a very happy married life.

I shall always remember the many pleasant drives you have taken me.

With kindest regards.

Yours Sincerely.
Dorothy S. Hewitt.

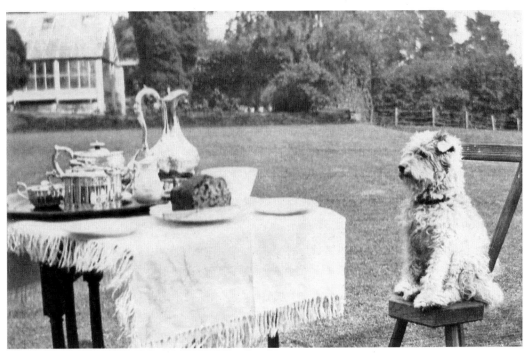

The Hewitt family pet, Spot the dog, has yet to yield to the temptation, but eyes the cake expectantly as he waits patiently in Serridge House garden on what appears to be his own chair.

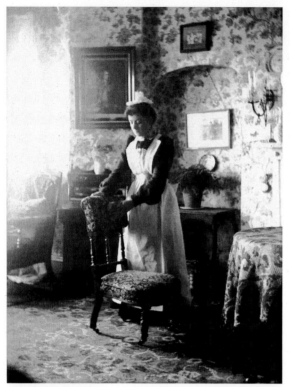

A posed Dorothy Hewitt photograph of a maid cleaning a chair in the drawing room of Serridge House, *c.* 1905. In 1901, George Colthurst Hewitt employed two servants: twenty-three-year-old Elizabeth Salfrey as house and parlour domestic and twenty-two-year-old Lillie Small as a cook/domestic. This is believed to be Elizabeth, as another picture of this maid in the collection records the name 'Eliza' on the reverse. By 1911 only one servant, twenty-five-year-old Bertha Eugenie Davis, from Great Bridge, Staffordshire, was looking after the house occupied by George, his sister Sarah Ellen, and niece Dorothy.

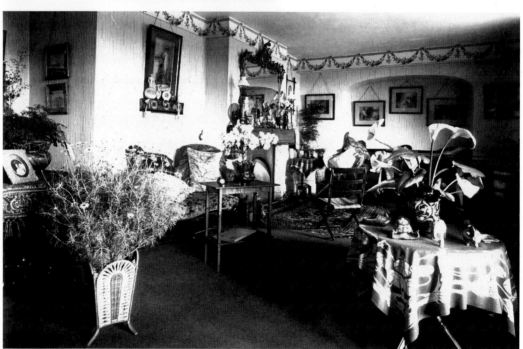

A still-life photograph of the interior of Serridge House. The careful arrangement of the furniture and the vase of lilies lends an air of tranquillity and order to the Edwardian room.

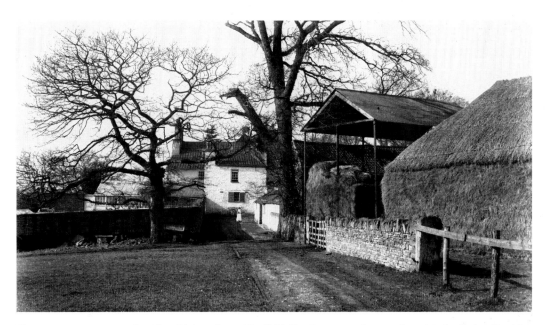

The rear entrance to Serridge House from Henfield Road passes the southern end of the Serridge farmyard. The 1841 census tells us that Henry Hewitt (son of William of Heath Cottage) and his wife Sarah were at Serridge House at this time, farming 150 acres. Here we see a beautifully thatched hayrick alongside the open barn (manufactured from recycled rail recovered from a railway line). A lady stands in the drive and the rooks are building their nests in the tall trees above the barn.

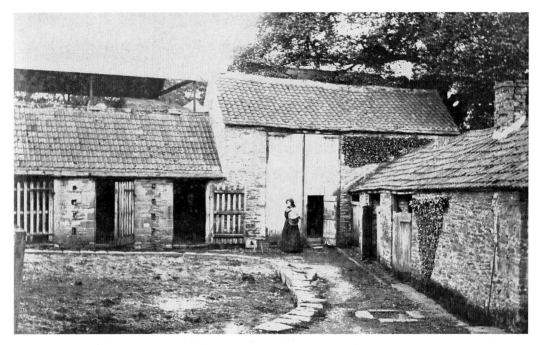

Serridge farmyard. The milkmaid with her pail has just left the barn and is about to pick up her three-legged stool and set off to do her daily task. At one time, the farm was an asset of the Coalpit Heath Collieries (later to be the Coalpit Heath Coal Co.).

This is a posed Dorothy Hewitt
photograph of a friend acting
as a milkmaid, coming from
the orchard into Serridge Farm.
Written on the reverse of the
original picture is:

'Bee' as a milkmaid. 'I'm going a
milking, Sir,' She said.

Note the stout tree protection,
and the metal and wire rope fence
attached to the gatepost, probably
recovered from one of the collieries.

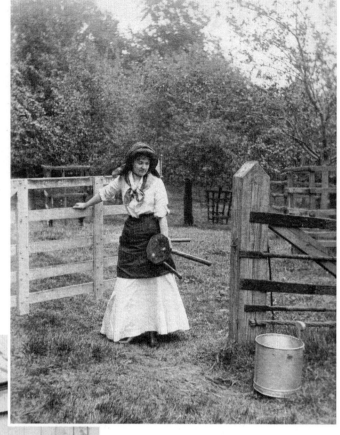

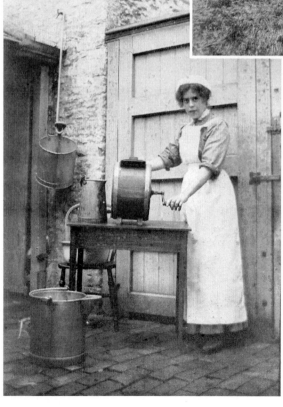

This Dorothy Hewitt picture is entitled
'Butter Day'. The composed and posed
photograph taken at Serridge House on
2 December (year unknown) at
12 p.m. was entered for a photographic
competition, as the reverse includes
Dorothy's name and address together
with technical details relating to the
picture. The camera used was a Ray
No. 9 1/4in plate with exposure F.11 at
15 seconds. The picture was developed
with M2 and printed on Paget S.T.
paper.

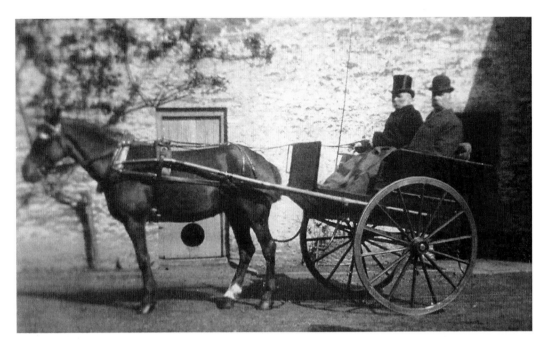

Two men on a horse-drawn two-wheeled unsprung cart in the yard of Serridge House pose to be photographed by Dorothy Hewitt. Possibly they are visitors to the Hewitt family, or perhaps it is a gentleman with his driver. Whichever, the pair appear ready to depart as the horse's hooves are freshly oiled and there is no sign of mud on either trap or equine. The circular hole in the door is an opening for dogs.

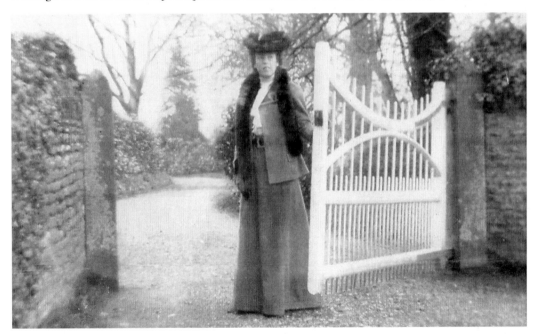

A well-dressed but unknown lady at the entrance gate of Serridge House. The extensively carved ornamental stone gateposts remain in place to this day. Looking south from Ruffet Road, with Serridge House in the distance.

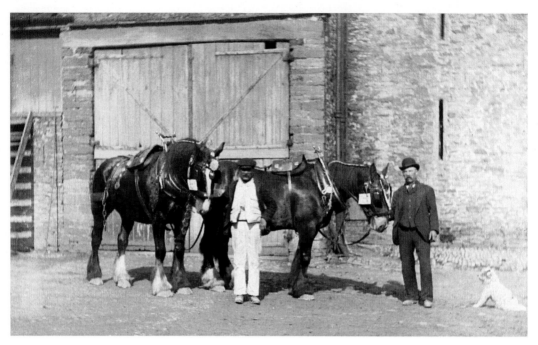

A pair of heavy horses, resplendent in their harnesses and brasses, standing with their handlers outside Serridge Farm barn.

The inner courtyard of Serridge House. A lady stands in the doorway under a timber canopy supported by elaborate brackets. There is a cupola-type structure at the ridge (partly obscured by a very tall chimney) and a rainwater fascia and gutter at the gable end

5

ORGANISATIONS

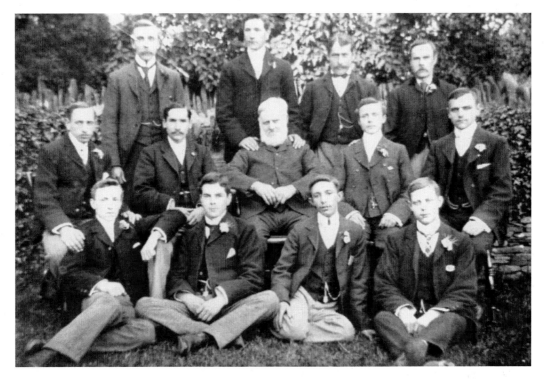

Pharoah John Hale, seated in the centre, and the well-turned-out members of his Zion Sunday school class. Pharoah, born in 1831 in Frampton Cotterell, was a coal miner prior to setting up a grocer's shop opposite Zion Chapel in the 1870s. He died in 1915.

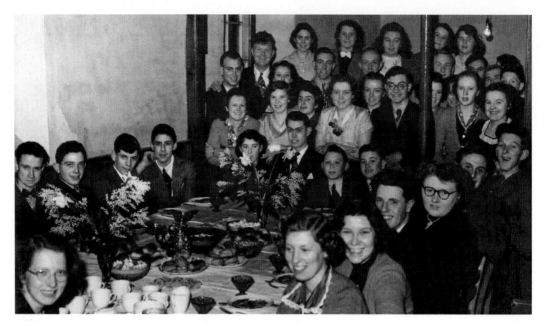

Zion Youth Club in the late 1940s. Seated around the table, clockwise from bottom left: Margaret Luton, Percy Greville, -?-, David Cook, -?-, Doreen Luton, David Smith, Bryan Lear, -?-, John Hacker, Michael Lewis, Jean Teagle, Fred Tovey, -?-, -?-. Standing in the front row, from left to right: Sylvia Dando, Elaine Evans, Rosemary Lloyd, Phyllis Luton, Kenneth Lloyd, Valerie Hanks, Jean Underwood.

David Winter-Alsop, Victor Bryant and John Dando are the three young men standing on the far left of the second row. Reg Hiscox, John Curnock, Michael Davis and Terry Dando are also in the picture.

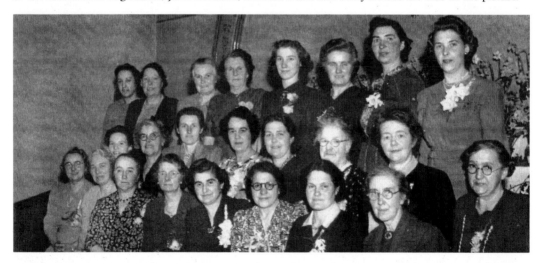

During the 'Daffodil Weekend', an annual festival held at Bethel Free Methodist Chapel, the chapel was decorated with spring flowers and the Bethel Ladies' Choir, trained by Mrs Ulman, presented an afternoon concert. This photograph of the choir is believed to have been taken in April 1947. From left to right, back row: Jean Mitchell, Phyllis Teagle, Alice Reece, Mrs Tovey, Jack Crew's wife, Mrs Gladys Stabbins, Bronwen Wilcox, Olive Dando. Middle row: Jean Goodfellow, Mrs Hopes, Mrs Howes, Bernice Cook, Ella Thompson (*née* Payne), Miss Dutfield, Mrs Howes, Mrs Greville. Front row: Nora Roach, Kate Crew, Norah Gifford, Mrs Clarke, Mrs Smart, Mrs Gay, Lilian Smart, Mrs Emily Smart.

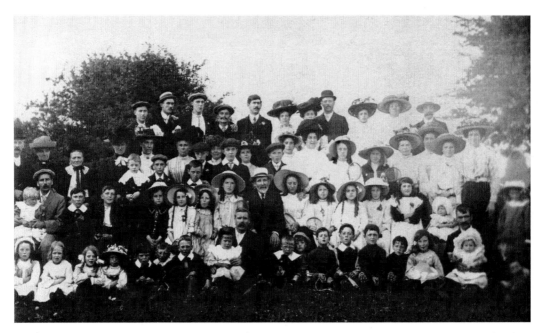

Adults and children of Bethel Chapel Sunday school, pictured around 1908 in the Free Methodist Chapel grounds, Woodend Road. The chapel, built in 1851, included a schoolroom, and the bearded gentleman wearing a light hat in the centre of the picture is John Tanner Green, superintendent of the Sunday school for nearly forty years. Born in 1838, the son of George and Ann Green, John (a coal miner) lived in Stone Close, Frampton Cotterell. He married Elizabeth Dutfield in 1862 and Hannah Maria Cole in 1892. He died 15 November 1914.

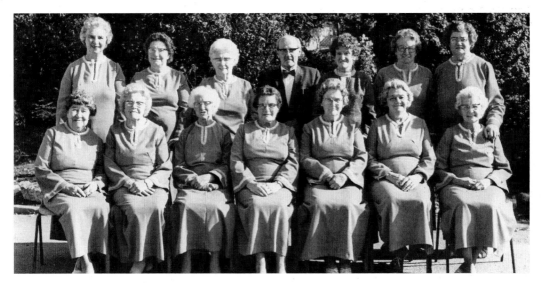

Coalpit Heath Silver Lining Choir, pictured in the 1980s, was very successful in winning certificates and trophies under the chairmanship of Edgar Lewis. From left to right, back row: Bronwen Wilcox, Blanche Adamson, Mrs Goodchild, Edgar Lewis (conductor), Kath Prosser (pianist), Phyllis May, Norah Brown. Front row: -?-, Mrs Halliday, Mrs Lowery (conductor), Lily Crew (conductor and pianist), Mrs Mabel Elson, Lilian Martin, Mrs Edith Lewis.

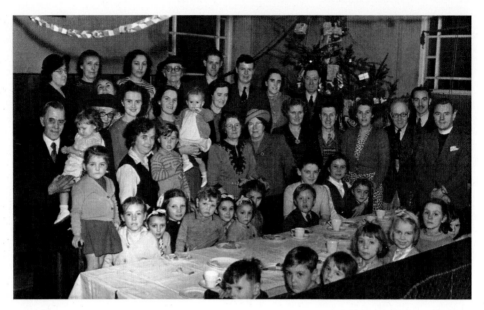

Bethel Sunday school Christmas party, 1950. From left to right, back row: -?-, Mrs Emma Mitchell, Jean Mitchell, Mrs Tanner, Jack Isaacs, Fred Tovey, Rene England, Mr England. Third row: Mrs Edith Goodfellow, Mrs White, Grace Seymour, Jean Goodfellow, -?-, Mrs Fry. Second row: Henry Dutfield, -?-, Edie Tovey (*née* Goodfellow), Keith Smith, Mrs Lily Clark, Mrs Roach, Mrs Gladys Stabbins, Mr Tovey, Olive Dando, William Pullin, Mervyn Dando, Revd Joseph Law (minister). First row: Vera England, -?-, Christine Excell, ? Wilden, ? Wilden, ? Excell, -?-, Mavis Short, -?-, Pamela Claydon, Ann Wilcox, Grace England. Front Row: -?-, Terry Claydon, -?-, -?-, -?-, ? England, -?-.

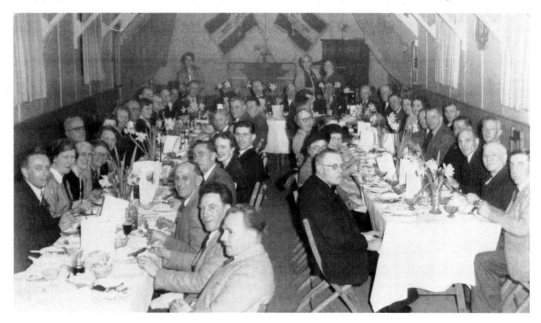

Members of Frampton Cotterell Royal British Legion sit down to a meal in the original Memorial Hall, Ryecroft Road, in 1952. Muriel and Max Evans, Nancy and Harold Churchman, and Connie Holbrook have been identified enjoying the repast.

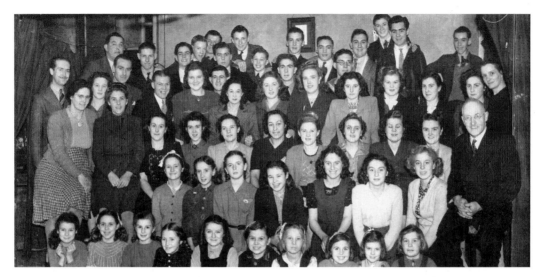

Members of Bethel Youth Club, who met on Wednesday evenings, photographed in January 1948. From left to right, back row: Bill Mitchell, Jack Isaacs, Ronald Lowe, ? Batten, -?-, Fred Tovey, Brian Tovey, Fred Napthine, Bob Semple, Bill Powell, John Gifford, -?-, Peter Blanchard, -?-, -?-, ? Pritchard. Third row: Bert Goodfellow, Barbara Greenaway, Mervyn Dando, Ivor Tovey, Ella Nicholls, Graham Brown, Jean Crew, Diana Stabbins, Roma Nelson, Pamela Burnett, Brenda Jones, Jean ?, Vera Hale, Mrs Olive Lowe. Second row: -?-, Olive Dando, Violet Blackmore, -?-, Jean Goodfellow, Jean Mitchell, Joan Batten, Maisey Lewis, Lorna Jones, Grace Seymour. First row: Shirley Dutfield, Kathleen Tovey, Mary Found, -?-, Diane Tovey, Iris Drew, Hazel Williams, William Pullin. Front row: Joyce Tanner, Marion England, Maureen Dutfield, -?-, Jean Tovey, Ann Wilcox, Margaret Payne, Sheila Lewis, -?-, Joy Cook.

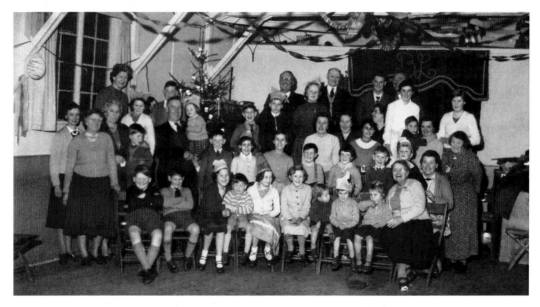

This Christmas party in 1950 is for the children of Frampton Cotterell Royal British Legion members. In the picture are: Nancy Churchman (third lady from the left), Christopher May (second from left, front row), Mrs Milsom (far right, front row), Mr Milsom (standing at the back, without glasses) and Mrs Lear (far right, holding her son Philip). Connie Holbrook is standing at the back, in front of the window.

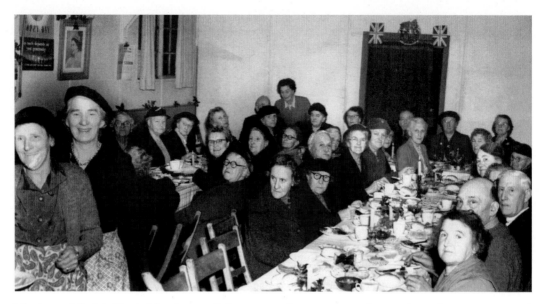

Members of Coalpit Heath Silver Lining Club enjoying afternoon tea in the Royal British Legion Memorial Hall, *c*. 1953. Mrs Lillian Axford and Mrs Kate Crew are the ladies standing at the front. Mrs D. Stainer, Mrs E. Lewis, Mrs F. Lewis and Mrs M. Lewis are amongst those sat at the table on the left, with Mrs May?, Mrs Marsh and Mrs Woodruff seated around the table on the right. The Silver Lining Club was formed by Mr Bert Cane, manager of the Frampton Cotterell Co-operative Store, and their first meetings were held in the meeting room above the store in Woodend Road.

Members of St Saviour's Mothers' Union celebrate its sixtieth anniversary. Back row, from left to right: Veronica Simmons, Betty Webb, Connie Holbrook, -?-, Doreen Willis, Elsie Gratton, Christiana Poole, Mabel Elson, Jean ?, Mrs Laing, Stella Long, E.M. Woolley. Front row: Ruth Smart, Daisy Tovey, -?-, Doris Lear, Norah Rodman, Eileen Whittern, Daisy Griffin, Eileen Witchard.

The congregation of Hebron Primitive Methodist Chapel formed a choir during a miners' strike in 1925; concerts were given to raise funds for the needy colliers' families. This is the Hebron Gleemen choir, *c.* 1950. From left to right, back row: Mr Sherman, Oliver Dutfield, Fred Francombe, Trevor Gifford, Leslie Fry, Walter Batten, Percy 'Jim' Holway. Middle row: Frank Nicholls, Raymond Crew, Lloyd Crew, Roy Derrick, Mr Hunt, Redvers Bateman, Edward Gay, Ivor Moss. Front row: Reginald Crew, Alfred Crew, Herbert Adamson, Randolph Tovey (conductor), Adeline 'Addy' Lewis (pianist), Gilbert 'Dick' Lewis, Edgar Lewis, Herbert Tovey.

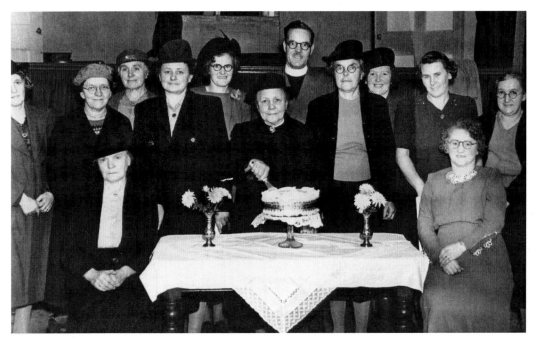

Wesley Bright Hour members pose for cake-cutting, *c.* 1948. From left to right, back row: Mrs Cook, Mrs Harris, Revd Lee, Mrs Bendle. Middle row: -?-, -?-, Mrs Nelson, Mrs Russell, Mrs Hopes, Margaret Hacker, Mrs Greville. Front row: Miss Alsop, Mrs Amy Teagle.

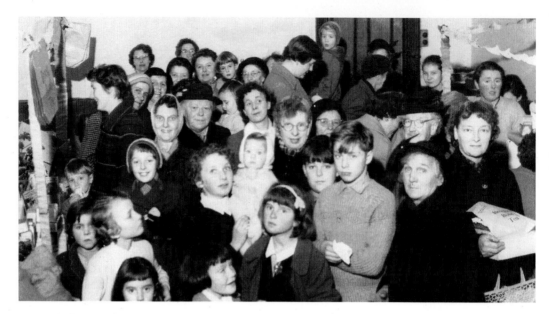

A crowd of eager 'shoppers' photographed at a Hebron Sale of Work, *c*. 1956. Children at the front, from left to right: Neville Lewis, Angela Gifford, Brenda Tovey, Esme Gifford, -?-, Sylvia Lewis, Gloria Tovey, Richard Curthoys, David Curthoys. Edna Tovey, holding baby Linda Tovey, is amidst the youngsters, with Phyllis Edwards, Mrs Gifford and Mrs Walters in the group of ladies immediately behind her. The three ladies in dark coats on the right of the picture are Mrs Tremlin, Miss Dutfield and Mrs Winifred Fry. Rachel Gregory and Christine Lewis are behind them. Audrey Lewis, Dorothy Lewis, Jean Young, Marlene Cox, Bernice Nelson and Florence Lewis are amongst those at the rear.

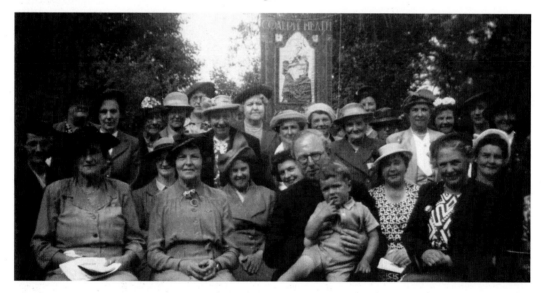

Coalpit Heath Mothers' Union photographed in 1934. Standing, from left to right: Mrs Rose Luton, Mrs Ashby, Mrs Butcher, -?-, Mrs Wheeler, Mrs May, Mrs Horace Drew, Mrs Drew, Mrs Ella Drew, Mrs Nichols, Mrs Ruth Smart, -?-, Mrs Rodman, Mrs Daniel Rodman, Mrs Phyllis Monks, -?-. Seated: Mrs Elsie Gratton, Mrs Wright, Mrs Tovey, Mrs Wordsworth-Wells, -?-, Mrs Naylor, Revd Vincent Clifton-Castle, Christopher Naylor, Mrs Rue, -?-, Mrs Nutt.

The cover of the Frampton Cotterell Male Voice Choir programme for the thirty-first annual concert, held on 24 March 1956 in Zion Church Hall. Founded in 1925, the conductor for many years was Albert Charles 'Charlie' Smith, who retired as conductor in the 1960s. Still very active, during the last twenty years the choir has raised over £7,000 for Cancer Research at the annual concerts.

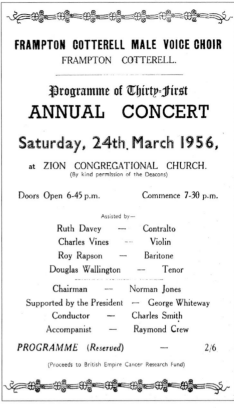

FRAMPTON COTTERELL MALE VOICE CHOIR
FRAMPTON COTTERELL.

Programme of Thirty-First
ANNUAL CONCERT

Saturday, 24th March 1956,

at ZION CONGREGATIONAL CHURCH.
(By kind permission of the Deacons)

Doors Open 6-45 p.m. Commence 7-30 p.m.

Assisted by—

Ruth Davey	—	Contralto
Charles Vines	---	Violin
Roy Rapson	—	Baritone
Douglas Wallington	—	Tenor

Chairman	—	Norman Jones
Supported by the President	—	George Whiteway
Conductor	—	Charles Smith
Accompanist	—	Raymond Crew

PROGRAMME (Reserved) — 2/6

(Proceeds to British Empire Cancer Research Fund)

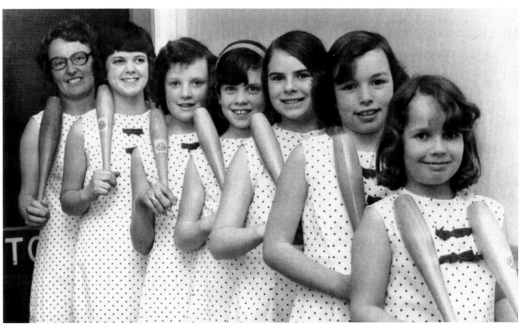

Bethel Club Swingers display group, c. 1970. From left to right: Isa Napier, Catherine Hunt, Julia Gudgeon, Elizabeth Edgecombe, Jacqueline Shaw, Sarah Vicarage, Jane Dymot.

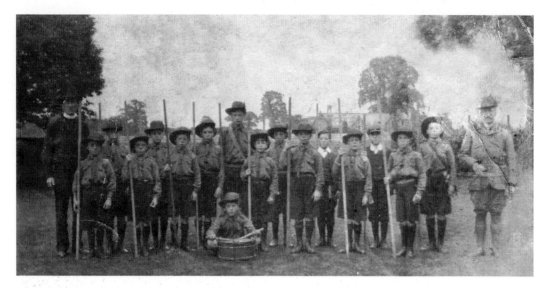

The first local Scout patrol, photographed in St Saviour's churchyard extension between 1908 and 1912. Following his experimental camp for teenage boys on Brownsea Island in 1907, Robert Baden-Powell established the Scout movement the following year and, in a very short time, Scout patrols were created up and down the country. By 1910 there were over 100,000 members. The Revd Ernest Phillips, vicar of St Saviour's, is the gentleman on the left, whilst the Scout leader on the right appears as though he is straight out of the Boer War, which ended in 1902. Albert Clarke, with a bugle, is standing next to the leader. The poles were used to aid jumping over walls and fences!

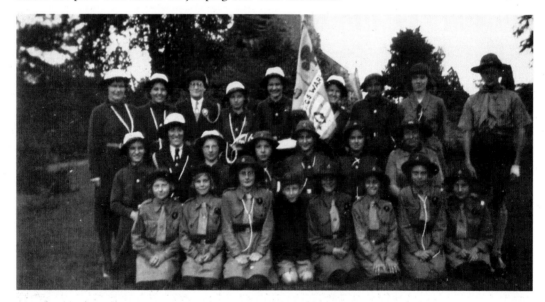

Sea Rangers, Girl Guides and a solitary Cub assembled at the back of St Saviour's vicarage in 1940. From left to right, back row: Connie Holbrook, Cynthia Woodey, -?-, Barbara Langley, Leah Williams, Ethel Excell, Jean Mitchell, Jean Knight, -?-. Middle row: Barbara Corcoran, Miss Wilcox, Enid Rodman, Geraldine Tye, Lucy Rodman, Kathleen Gale, Miss Hartfree. Front row: Dorothy Britton, Ann Wilcox, Pam Knight, -?-, -?-, Jacelyn Smith, ? Lear, -?-. Sea Ranger groups are known as crews and are named after ships; this one is Warwick.

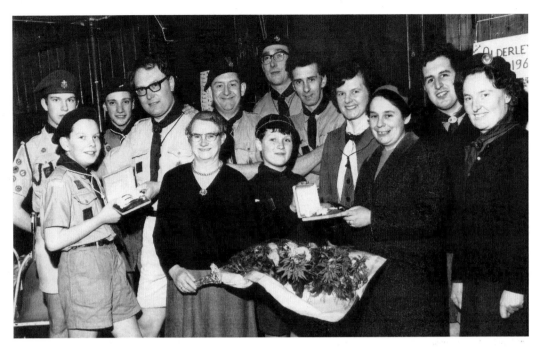

Members of 1st Frampton Cotterell Scouts give a presentation to Norma and Bob Doling, who are 'leaving for pastures new', February 1960. Left to right: Ken Tucker, Derek Howell, Paul Blackmore, Bob Doling, Mrs Wren, Joe Tullett, Bob Sandford, -?-, Bryan Pickering, Pam Pickering, Norma Doling, Tony Killbe, Isa Napier.

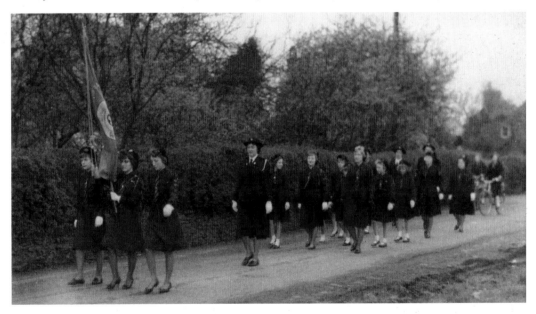

Frampton Cotterell Girls' Life Brigade photographed opposite the recreation field, Beesmoor Road, *c.* 1959. Leading the parade from left to right: Anita Dutfield, Sheila Wilcox, Edna Tovey. Captain Bernice Nelson is followed by, from left to right: Miriam Adamson, Esme Lewis, ? Turner, Susan Boulton, Brenda Tovey, -?-, Christine Lewis, Pamela Lewis. Officers Mrs Turner and Florence Tovey bring up the rear. The company met in the Wesley Chapel hall.

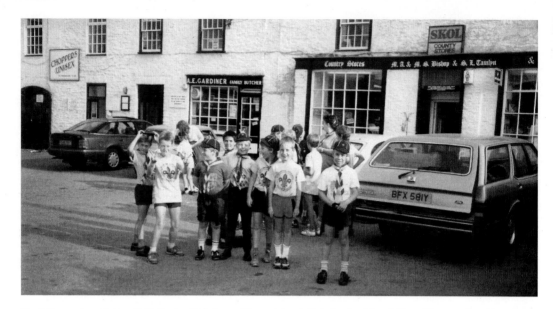

First Frampton Cotterell B Pack of Cubs, with assistant Cub leader Hazel Partridge, gathered in front of 'Country Stores', successor to the well-known L.J. Nelmes' grocery shop that had served Frampton inhabitants for many years. The Rodman family had been the proprietors prior to Leonard Nelmes. Alan Gardiner's butcher's shop is next door – now a fruit and vegetable retailer. The earliest site of shops in Frampton Cotterell, this picturesque group of eighteenth-century stores is located around an earlier cobbled stone yard in Church Road, opposite Frampton End Road.

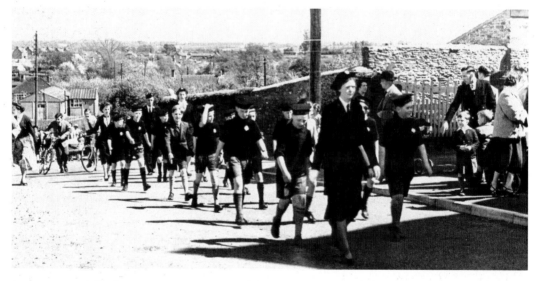

Frampton Cotterell Life Boys progressing up Woodend Road, around 1958, on their way to a service in Zion Chapel. Captain Ida Dutfield leads the company with Christopher Buston to her left, whilst bringing up the rear are, from left to right: Joyce Horton, Walter Batten (Boys' Brigade captain) and Bernice Nelson. The last three boys in the file nearest the camera are, from left to right: Melvin Burcombe, Rodney Axford, David Curthoys. Frank Smith is the man pointing towards the pavement. Life Boys, the junior section of the Boys' Brigade for lads aged between nine and twelve, wore a Naval-pattern cap with 'The Life Boys' on the ribbon, the lifebelt badge on the left breast, blue jersey and shorts, and black stockings with two saxe-blue rings.

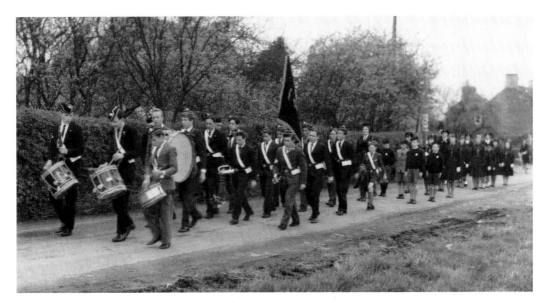

The 1st Coalpit Heath Boys' Brigade band head a parade, marching along Beesmoor Road in 1959 or 1960. From left to right: David Holway (solo drummer), Rodney Axford (side drum), Keith Smith (side drum), Ian Hanks, David Curthoys (base drum). Bugles: Darrell Scott, Captain Walter Batten, Alan Saunders, Brian Luton, Graham Wilcox, Melvyn Burcombe, Alan Lear, Richard Curthoys, Keith Gane, Paul Chaplin, Jonathan Davis, Malcolm Lewis. Captain Ida Dutfield leads a small contingent of Life Boys, followed by the Girls' Life Brigade.

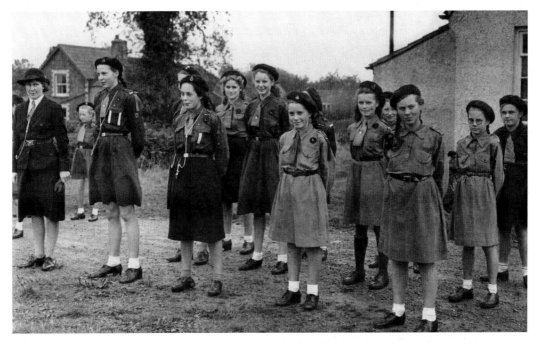

The 1st Coalpit Heath Girl Guides assembled at Rangeworthy in 1942. From left to right: Connie Holbrook (Guide captain), Ellen Luton, Norma Cruickshank, Jane Brookman, Gillian Davis, Margaret Loosley, Primrose Thornell, Zelda Dicks, Ann Monks, Norma Davis, Marlene Thomas.

The presentation of 1st Class Guide badges to members of the 1st Coalpit Heath Girl Guides at the old Guide hut, Rose Oak Lane, in 1942. From left to right: Gillian Minns, Barbara Eaves, Connie Holbrook, Mrs Lister (district commissioner), Miss Grey (county commissioner), Ellen Luton, Glenys Wilcox, Norma Cruickshank.

The committee in charge of organising the Frampton Cotterell festivities to celebrate the Coronation of Edward VII, photographed in June 1902. From left to right, back row: Robert Horder (inn keeper, Horseshoe Inn), George Skidmore (market gardener, Goose Green), Edwin Curtis (builder, Harris Barton), E. Drew, Fred Howes (beer retailer, Rising Sun), Abraham Winter Brookman (shopkeeper/butcher, Parsonage Farm), F. Harding, Frederick Holder jnr, J. Newman. Second row: C. Newman, E. Niehaus, J. Lewis jnr, William Meredith (farmer, Gloucester Road Farm), William Gibbs (assistant overseer and tax collector, Frome House), R. Johnston, Isaac Davies snr, Frederick Holder snr (market gardener, Frampton Common). First row: William Tugwell (baker, Woodend), J. Fowler, Alfred W. Cam (farmer, Cog Mill Farm), J. Lewis snr, Dr Reginald Eager (superintendent, Northwoods Asylum), Henry Gibbs (farmer, Perrinpit Farm), John Long Champion (grocer/shopkeeper, Gladstone House), William Hardwick (farmer, Hillside House), George Colborn (grocer and postmaster, Ryecroft House). Front row: Charles F. Egglestaff (farmer, Park House), Alban R. Cohen (elementary schoolmaster, National School), Jeffrey Matthews (farmer, Swan Lane), John Alfred Mayer (certified schoolmaster, Firleigh Villa), Isaac Davies jnr.

6

THE FOOTE FAMILY

The grave of Joseph Foote in old Torrens Street Cemetery at Richmond, near Hobart, Tasmania. Born in Frampton Cotterell in 1791, Foote, the agent of the Van Diemen's Land Colonial Missionary Society in that district, died at Richmond on Monday, 10 July 1848. The man leaning on the fence is thought to be his eldest son, John Clarke Foote.

The children of Joseph and Elizabeth Foote of Frampton Cotterell. Clockwise from top: Lucy (1833-1895), John Clarke (1822-1895), Joseph (1831-1890), Harriett (1837-1922), James (1829-1895), Alfred William (1823-1896). Centre: Clarissa (1825-1899).

Joseph Foote married Elizabeth Clarke on 22 January 1821 in St Philip and Jacob Church, Bristol. Five of their offspring – James, Clarissa, Joseph, Lucy and Harriett – were baptised 23 July 1837 at St Peter's Church, Frampton Cotterell. In the 1841 census, the family are listed as living in Footes Lane, Frampton Cotterell, with Joseph's occupation described as hatter. Elizabeth left Plymouth on the barque *Emigrant* with her adult children James, Clarissa, Lucy, Harriett, and John and his wife Mary Ann, arriving at Moreton Bay on 8 August 1850. The passenger list states that there were already two sons in Launceston, Tasmania.

Believed to be a photograph of Joseph Foote snr. An early colonist to Van Diemen's Land, Foote arrived on 31 January 1848 at Launceston, aboard the barque *Britannia* from London. He was an agent of the Colonial Missionary Society, an organisation formed in May 1836 as a 'distinct society for the Colonies' following the report of a deputation to Canada by representatives of Congregational churches from Britain. Its principal mission was directed towards promoting Congregationalist forms of Christianity among 'British or other European settlers' rather than indigenous peoples. Foote collapsed in the Congregational Chapel at Richmond on Sunday, 9 July 1848, while preaching the Gospel to his congregation which comprised many convicts. He died the following evening.

Benjamin Cribb, born 7 November 1807 at Poole, Dorset, originally manufactured blacking and sold household appliances and matches in Covent Garden, London, before going to the Moreton Bay district of Queensland, Australia. Arriving in 1849 on the *Chasely* with his first wife Elizabeth Brideson, their three children, and his niece Mary, Benjamin began business in Ipswich as a general merchant that same year. His wife died in 1852 and the following year he married Clarissa Foote. In 1854 he joined in partnership with John Clarke Foote, his wife's brother, and Robert Cribb jnr, his nephew, establishing the firm of Cribb & Foote – the first retail business in Ipswich. He was a member of the New South Wales Legislative Assembly (1858-1859), and Queensland's Legislative Assembly on two occasions (1861-1867 and 1870-1873). An ardent Congregationalist, he was a Sunday school superintendent, as well as being a driving force behind the establishment of the Ipswich Boys' Grammar School. Benjamin Cribb died of a stroke whilst attending a service at Ipswich Congregational Church on 11 March 1874.

Clarissa Cribb, the eldest daughter of Joseph and Elizabeth Foote, married Benjamin Cribb at the United Evangelical Church, William Street, Brisbane on 30 March 1853. The couple had nine children. When her husband died suddenly in 1874, Clarissa became the senior partner in the firm Cribb & Foote, but in 1891 she and her brother John retired to allow younger members of the families to come in. Clarissa died at her residence, Denmark Hill, Ipswich, Queensland on 14 December 1899. She was seventy-four and had been ailing for some years. The Cribb & Foote establishment was closed for her funeral and about 120 employees, many of them carrying wreaths, preceded the hearse to the cemetery. About forty relatives walked behind the hearse. The photograph was taken in Sydney, New South Wales, around 1855.

John Clarke Foote, born 10 July 1822 in Calne, Wiltshire, was the eldest son of Joseph and Elizabeth Foote. He married Mary Ann Hardwick at St Saviour's Church on 4 April 1850. At the time of his marriage, his occupation is described as herdsman. John arrived at Moreton Bay, Queensland, in 1850 and was appointed manager of Benjamin Cribb's London Stores, Ipswich, in 1852; he was admitted into partnership in 1854. On the death of Cribb in 1874, John and his sister Clarissa (Cribb's widow) carried on the business until 1891, when the firm passed to the control of their sons, Messrs T.B. Cribb, J.F. Cribb, J.C. Cribb, H.R. Cribb, Ambrose J. Foote, William H. Foote and Joseph Foote. John was a member of the Queensland Legislative Council from May 1877 to August 1895. He died 18 August 1895 at Ipswich.

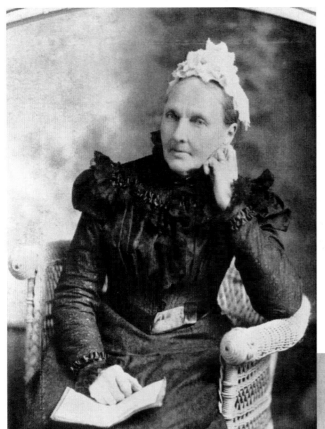

Mary Ann Foote (*née* Hardwick), born around 1829, was, according to the *Emigrant*'s passenger list of 1850, the daughter of John and Elizabeth Hardwick of Ram Hill, Coalpit Heath. Mary Ann married John Clarke Foote and bore him eleven children, all born in Queensland, six of whom survived into adulthood: Marianne Lucy (1854-1932), Ambrose John (1856-1920), William Hardwick (1858-1829), Harriett (1860-1886), John Clarke (1861-1861), Eliza Ann (1862-1949), John Albert (1864-1865), Joseph (1866-1943), Clarissa (1867-1868), James Benjamin (1869-1869), Arnold Charles (1872-1875). Mary Ann Foote died 4 July 1904 and is buried in Ipswich General Cemetery, Queensland.

Alfred William Foote (born 4 November 1823) and his wife Eliza Ann (*née* Yeates) with two of their children: Elizabeth (born 1856) and Edith Esther (born 1876). Alfred and Eliza were married on Wednesday 4 February 1852 at Trinity Church, Launceston, Tasmania. Alfred had arrived in Tasmania in August 1841 on the ship *Arabian*, and for a time engaged in farming pursuits, before crossing to Victoria at the time of the gold rush; he subsequently went to Queensland. He was engaged as an accountant for Benjamin Cribb in Brisbane, farmed at Warrill Creek (which occupied his attention for seven or eight years) and afterwards became accountant for the firm of Cribb & Foote. Alfred died aged seventy-three from heart failure on 22 July 1896. His wife Eliza Ann died 14 November 1915 in her eighty-third year.

Joseph Foote jnr left Frampton Cotterell in 1848, aged eighteen, and arrived at Port Phillip Bay (now Melbourne), Victoria, on 18 August 1848. On his arrival in Tasmania he found that his father had collapsed in the pulpit and died the previous year. Joseph left Tasmania in 1851 for California, where he was successful on the goldfields; however, as the climate did not suit him, he returned to Australia and carried out mining in Victoria for some time. Subsequently he moved to Queensland. On 28 April 1863, Joseph married Esther Trotman (1829-1911), the second daughter of Samuel Trotman of Poplar House, Bristol, and for a number of years was connected with Messrs Cribb & Foote's establishment. Joseph died at his residence, Denmark Hill, Ipswich on 11 January 1890, aged fifty-eight.

James Foote, the third son of Joseph and Elizabeth, emigrated to Moreton Bay in August 1850, aged twenty-two. He first worked at Cribb & Foote and later became a grocer and an ironmonger. He married Catherine Keith (née Cramb) on 21 July 1863 at Clyde Bank Cottage in Brisbane. By 1876 the couple were living at Bleak House in Newtown, Ipswich. James owned a large area of land and was responsible for building Frampton Villa, located on the corner of Whitehill and Rose Streets, Eastern Heights, Ipswich. James Foote was a member of the Queensland Legislative Assembly on three separate occasions, an Alderman of Ipswich City Council, and Mayor of Ipswich in 1870. He died 4 September 1895 and is buried in the Congregational section of Ipswich General Cemetery.

7

SPORT AND PASTIMES

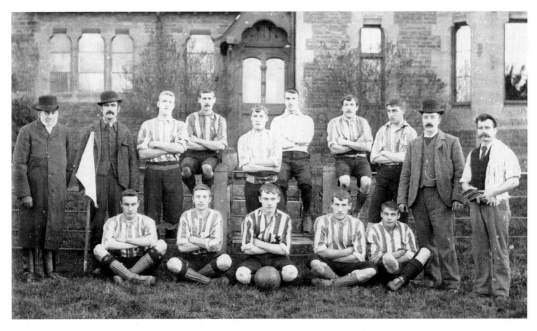

Coalpit Heath Football Club, season 1901/02, assembled in front of the Manor School. From left to right, back row: Revd Frederick William Griffiths (president), Oliver Adams (linesman), Maurice Tremlin (right wing half), W. Dee (centre half), W. Rowland (goal), F. Britton (back), G. Graham (left wing half), Jonathan Bryant (treasurer), T. Drew (trainer). Front row: A. Newman (secretary and right wing), A. Tovey (vice-captain and right wing), Alfred Blanchard (captain and centre forward), C. Dando (left wing), B. Master (left wing).

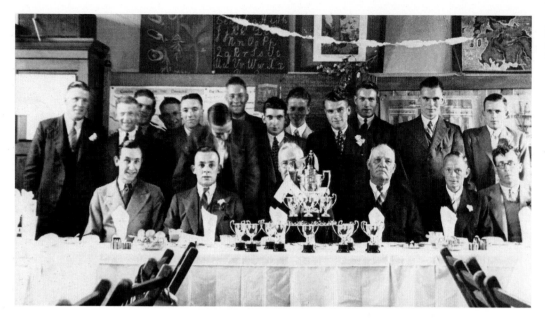

Frampton Cotterell United Football Club held a victory dinner at the National School on a Saturday evening in honour of the team winning the 3rd Division Suburban League Championship 1936/37. Seated from left to right: L. Reed, A. Curtis, Revd Charles A. Machonicie, E. Curtis, W. Harbourne, Les Bowyer. Vic Eaves is standing second from right. Other members of the team who played that season were: C. Brown, D. Cole, A. Gifford, H. Hall, T. Hall, L. Holder, F. Lewis, R. Luton, E. Thornell, H. Tovey and Herbert Tovey.

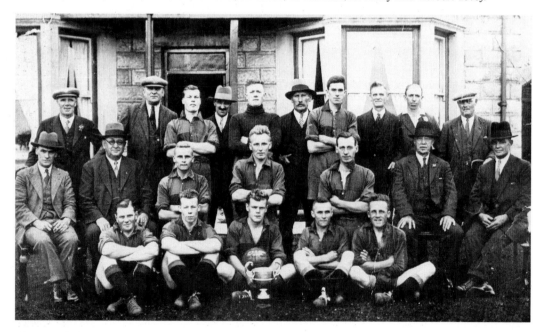

The now defunct Coalpit Heath Corinthians, who won the Bristol District League 3rd and 4th Division titles in the early 1930s. From left to right, back row: A. Slop, B. Talbot, K. Eames, H. Gifford, S. Crewe, C. Dando, A. Langley, O. Tovey, C. Batten, Ethelbert 'Bert' Cook. Middle row: M. Sage, F. Stone, Herbie Skidmore, J. Blanchard, W. Crew, J. Bryant, M. Wilcox. Front row: Leslie Cook, A. Barron, D. Wilcox, E. Elkes, C. Dando.

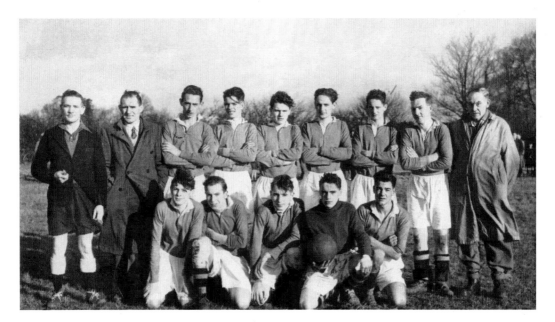

Frampton Cotterell under-eighteens football team, 1946/47. From left to right, back row: the referee, Tom Price (team manager), David Ashby (outside right), Ronnie Lowe (left back), Peter Freeman (inside left), Desmond Penny (left half), Brian Penney (outside left), Peter Blanchard (right back), Bill Griffiths (carried bucket and sponge). Front row: Don Thomas (right half), Brian May (inside right), Bill Burnock (centre half and captain), John Gifford (goalkeeper), John Brown (centre forward).

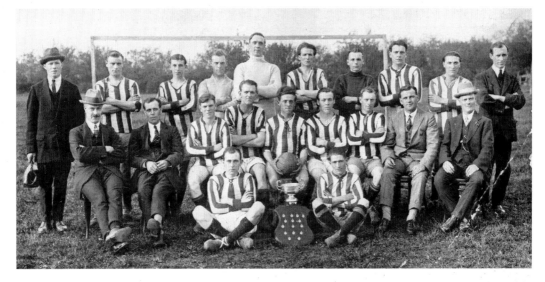

Coalpit Heath football team photographed in a field at the back of the Half Moon public house, season 1923/24. The side were winners of the Kingswood and District League. From left to right, back row: Joe Napthine (trainer), Morley Drew, Alec Batten, Charles Bisp, Alfred Elliott, Alec Smart, Jack Barrington, Reginald Green, Eric Dee, Gilbert Moseley (committee member). Middle row: Daniel Eames (committee member), Alfred George Green (committee member), Leslie Cook, Alan Smart, Howard Stabbins (captain), Joe Tovey, Archibald Newman, George Stone (president), Ethelbert Cook (committee member). Front row: Herbert Dando, Jack Eastman.

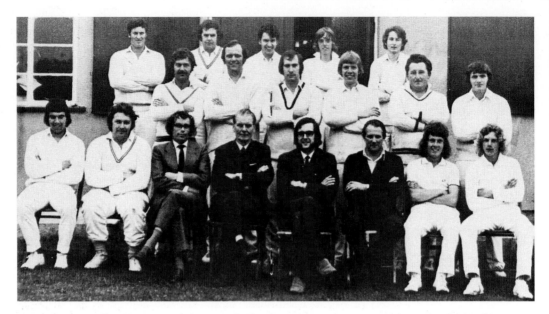

Frampton Cotterell Cricket First XI, photographed in the summer of 1974 to celebrate the club's golden jubilee. From left to right, back row: Colin Howes, David Luff, Vic Cater, David Elliott, Rodney Cragg. Middle row: Paul Gosling, Stuart Moseley, Mike Tilzley, Mike Burns, Tom Jenkins, Stephen Sheppard. Front row: Andrew Tomkies, Paul Skidmore (captain), Robert Wills (hon. treasurer), Victor Eaves (chairman), Andrew Eaves (hon. secretary), John Seymour, Neil Wren, Adrian Walters. The club was founded in 1924 under the leadership of Edward Methuen Forrest, headmaster of the Church of England School.

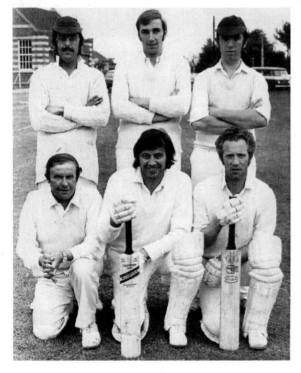

The Coalpit Heath Cricket Club team that competed in a Sixes tournament at Whiteshill Common, Hambrook. From left to right, back row: Ray Crich, John Symons, Alan Jones. Front row: Frank Thornell, Clive Lewis, Peter Seaman.

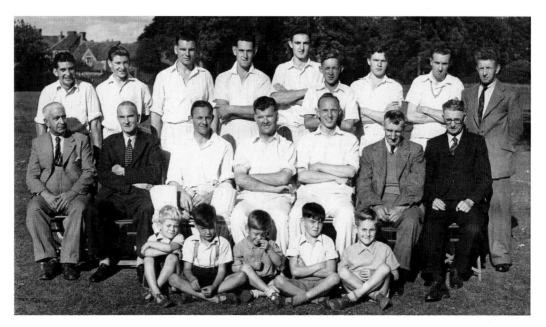

Frampton Cotterell Cricket Club, season 1946/47. From left to right, back row: ? Cole, -?-, Vic Eaves, -?-, Brian Kislingbury, -?-, -?-, -?-, Joe Shute. Middle row: -?-, Mr Leslie Kislingbury, Arthur Curtis, Arthur Nelmes, Tudor Dando, Harry Gifford, -?-. Front row: -?-, John Nelmes, -?-, -?-, -?-. Arthur Nelmes was also a Gloucestershire Football Association referee.

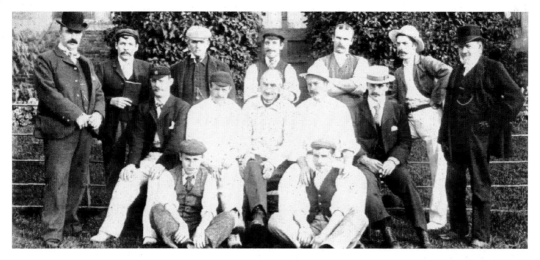

Coalpit Heath Cricket Club, photographed outside the Manor School in 1901. From left to right, back row: J. Bryant (hon. treasurer), F. Tovey, J. Crew, Samuel Bateman, G. Smart (vice-captain), C. Newman, Revd Frederick William Griffiths. Middle row: Ethelbert Cook (hon. secretary), C. Tremlin, F. Cook (captain), G. Watson, Bert Tremlin. Front row: F. Fowler, H. Alsop.

Bert Tremlin, born 18 September 1877 at Westerleigh, was a professional cricketer with Essex who made his County Championship debut against Derbyshire on 13 August 1900 and played his final game for the club on 25 August 1919 at Clifton College Close against Gloucestershire. A right-hand batsman and right-arm medium-pace bowler, he represented the MCC between 1911 and 1913. Following his retirement he became an umpire, officiating in forty-seven first class matches. He died in April 1936 at Woodford, Essex.

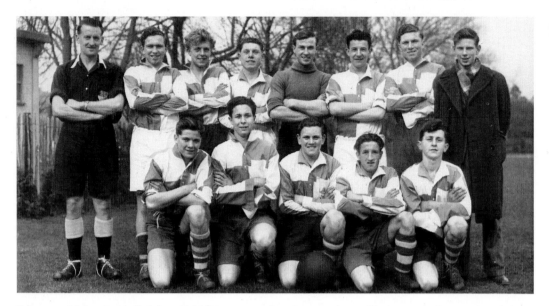

Frampton Athletic Football Club in 1950/51, wearing their distinctive emerald green and white quartered shirts. From left to right, back row: the referee, Clive Luton, -?-, Bryan Lear, -?-, David 'Pop' Bishop, Jimmy Warren, Dennis Eastman. Front row: John Lewis, Trevor Griffiths, Cyril Lowe, Noel Pritchard, Jack Eastman?. The club was launched as a youth team in the South Gloucestershire League in 1946 and provided six members of the representative team during the 1950/51 season, after gaining many divisional and cup honours.

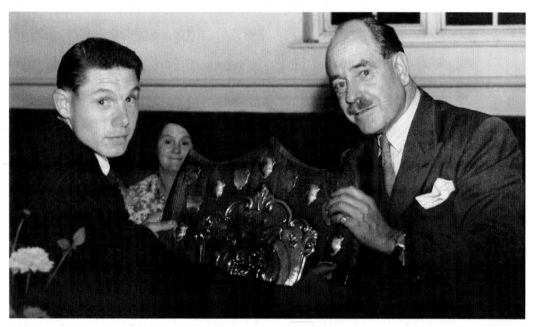

Frampton Athletic Football Club's trophy presentation evening at the Green Dragon public house in Downend. The youth team had a successful 1950/51 season, winning the Bristol and Suburban League Cup and Gloucestershire Youth Shield, which captain Bryan Lear is being presented with in the photograph. The team first played on a small pitch near Bitterwell Lake, before moving in 1960 to their present headquarters at Beesmoor Road.

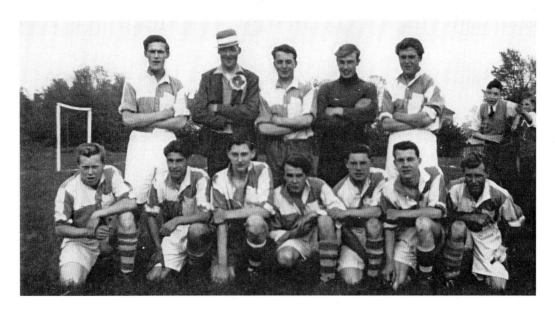

Frampton Athletic Football Club, season 1950/51. The club enjoyed a particularly successful period in the early 1950s, with this team being South Gloucestershire League champions, Bristol Suburban League champions, and Gloucestershire FA Youth Shield winners, remaining unbeaten for two seasons. From left to right, back row: Ivan Coles, Jack Shaw, Gordon Richardson, George Washbourne, Brian Maggs. Front row: Ken Hobbs, Cyril Lewis, John Taylor, Frank Thornell, Bryan Lear, Tom Jones, Gordon Tanner.

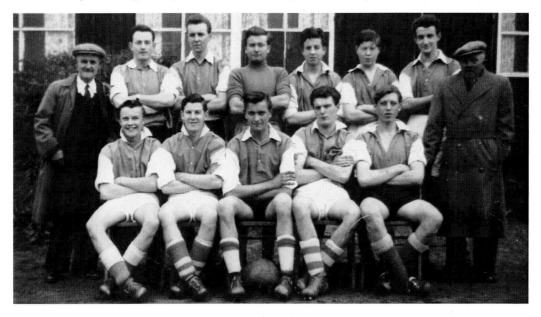

Frampton Cotterell Juniors under-sixteens football team, pictured in Beesmoor Road playing field, 1956. From left to right, back row: Frank Smart, Eric Demania, Terry Bryant, Mike Davis, Peter Pointer, Terry Williams, Ronnie Maggs, Mr Luton. Front row: Morian England, John Lewis, Dave Cordy, Roy Taylor, Reggie House. Behind the team is the original pavilion and changing rooms that stood in the corner near the Woodend Road entrance to the playing field. Known as the 'Green Shed', hot water for baths after matches was provided by Mrs Frank Smith, who lived in Woodend Road, at the junction with South View.

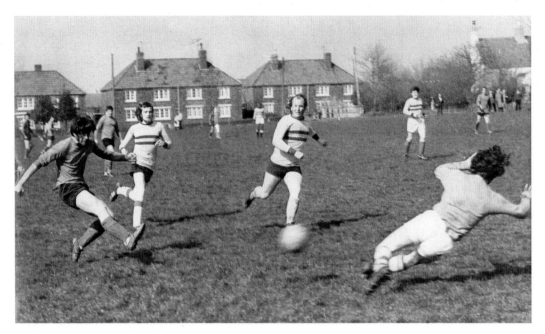

Frampton Athletic's centre forward, Tony Nelmes, shoots for goal during a home match on the recreation field, Beesmoor Road. Woodend Road is in the distance. Nelmes joined the club from Tytherington Rocks and was a prolific goal-scorer for a Frampton side during a period when the team scored more than 200 League goals in season 1969/70.

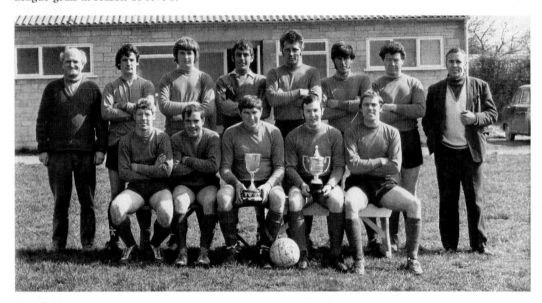

In season 1969/70, Frampton Athletic FC were Bristol and District League Division 4 champions and Berkeley Hospital Junior Cup winners, beating Nicholas Wanderers Reserves 4–0 in the final at Winterbourne. From left to right, back row: Jack Sage (manager), Barry Anstey, Chris Nelmes, Ray Crich, Tony Nelmes, Terry Williams, Frank Smith (chairman). Front row: Ronnie Barron, Cliff Dix, Joe Cake (captain), John Lewis (vice-captain), Roger Farrant. The celebration dinner and dance was held at the Half Moon public house, with the trophies presented by Bristol City secretary Bert Bush and footballer Gerry Sharpe.

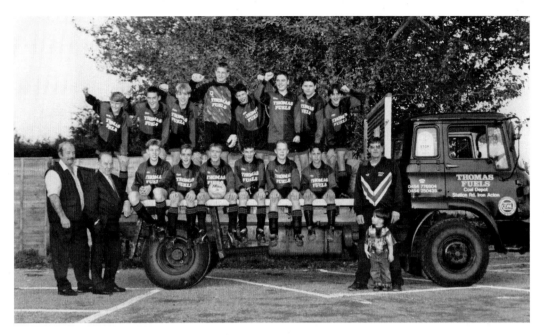

Frampton Rangers Juniors FC proudly display their new football kit, sponsored by Thomas Fuels of Iron Acton in 1991. From left to right, back row: Darren Edwards, Simon Tovey, Alistair Williams, Tony Court, Petar Jankovic, Danny O'Mally, Adam Nelson, -?-. Front Row: Keith Thomas, Mr Thomas, Gavin Ball, Mark Viner, David Scutt, Martin Tozer, Matthew Robbins, Gino Nelmes, Tony Nelmes (manager) and his grandson James Smith.

MAKE A DATE!!

SATURDAY NEXT

June 6th

FRAMPTON COTTERELL PONY GYMKHANA

IN THE PARK SCHOOL ROAD
FRAMPTON COTTERELL

Starting at 10.30 a.m.

✿ SIXTEEN EVENTS
 Silver Cups and Prize Money for all Events

✿ MUSICAL RIDE by members of the
 BANWELL HUNT PONY CLUB

All Classes – Novelty Events

✿ VALUABLE AUTOGRAPHED TABLECLOTH TO BE
 RAFFLED

✿ HUMPTY TRAIN RIDES ✿ BINGO

✿ BALLOON RACE ✿ CHILDREN'S CRECHE

Hot Dogs – Teas – Refreshments
 Licensed Bar applied for

GRAND DRAW FIRST PRIZE £40

EVENING DANCE this year will be held on the
Field in the Refreshments Tent with BAR.

In the 1960s and '70s, pony gymkhanas were regular and popular events in the area. This one, in The Park, School Road (advertised in the *Gazette* newspaper of 30 May 1964) had the added attraction of bingo and rides in the Humpty Train. An annual event from 1960 to the early 1970s, it was organised by local residents and organisations such as the local church, Scouts and youth club. Mr Alfred Nichols' field, opposite the Star in Church Road, was another venue for gymkhanas.

Members of the Berkeley Hunt meet at Perrinpit Farm, home of the Weaver family, in January 2005. Mounted hunt staff, from left to right: Chris Maiden (huntsman), Bob Blake (joint-master), -?-, Ben Slee (whipper-in). Hounds and foot followers wait patiently whilst the riders enjoy a stirrup cup prior to moving off to hunt in the surrounding 'country'.

The Berkeley Hunt meet at Poplars Farm, Perrinpit Road, on Wednesday 24 November 1999. Mounted followers gather at the rear of the farmhouse owned by the Colwill family, who have farmed in Frampton Cotterell since 1912. From left to right: Alan Underwood riding 'Major Charles', John 'Buster' Daniels (unmounted), -?-, Ian Camm, Jean Spratt (assistant hunt secretary), -?-.

8

MINING

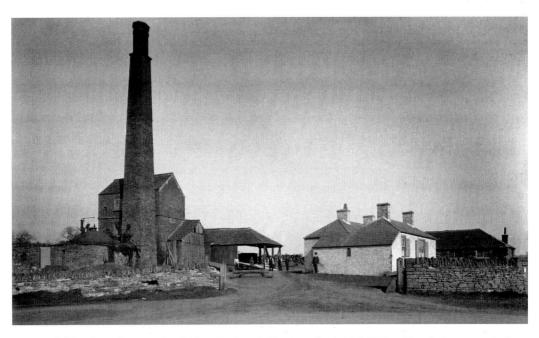

A remarkably clear photograph of New Engine Colliery, sunk about 1825, with what appears to be a haystack boiler to power the beam engine housed in the building behind the chimney. The bowler-hatted man is standing in front of the whitewashed weigh house, with the timber yard further behind. At the time of the photograph, around 1905, the colliery had ceased the production of coal, and the site of the works was converted for use as a saw mill for pit props, and workshops for blacksmiths and carpenters, to service Frog Lane and Mayshill collieries.

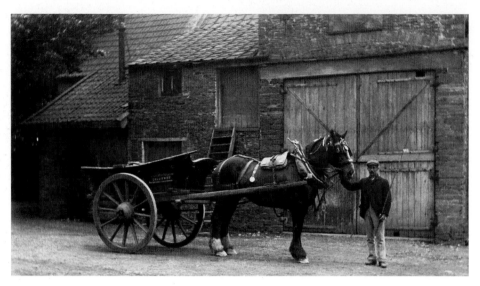

A heavy horse and cart of the Coalpit Heath Coal Co. stand in front of Serridge Farm barn. There are split doors and steps to the loft – for those with a good sense of balance, as there is no handrail to hold for ascent and descent. Combinations such as these transported hay and food on a daily basis to the pit head at Frog Lane for the horses working underground. The name Coalpit Heath Coal Co. Ltd (from 1900 to 1926) collectively applied to three collieries, Frog Lane, Mayshill and Nibley.

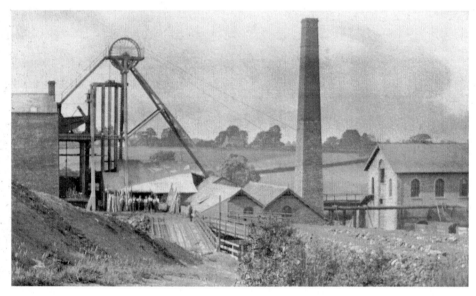

A general view of the pit head at Frog Lane Colliery, c. 1900. The housing of the Cornish beam pumping engine can be seen on the left; the outside of the beam is in the raised position, with the winding engine house on the right of the picture. The colliery was sunk by the Coalpit Heath Collieries early in the 1850s. There were three separate sites: Frog Lane for winding and pumping, Mayshill for ventilation and Nibley for additional pumping. The earliest record for Frog Lane Colliery is in the Mines Inspectorate's report for 19 July 1853, when George Flook, a sinker, overbalanced whilst he was plumbing the shaft.

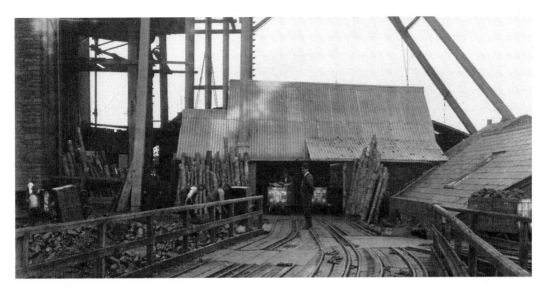

Thought to have been taken around 1906, this photograph gives a detailed view of the pit bank which was unchanged for the eighty-plus years of the colliery's life. There were very few, if any, changes to the layout of the double-gauge tracks, so laid to accommodate the different gauges of underground drams and surface trucks. Judging by the length of the timbers waiting to be sent to the coal face, it would appear that the seams in production are of a generous thickness. There are underground photographs indicating that some workings were in excess of 6ft thick.

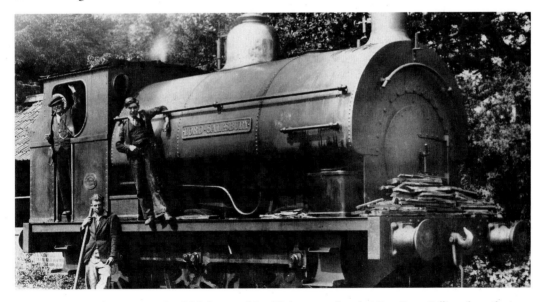

One of two steam locomotives, *Lord Salisbury* and *Lord Roberts*, employed at Frog Lane Colliery from the turn of the twentieth century to the 1940s, at Henfield yard, near Bitterwell Lake. The 0-6-0ST saddle tank engine was built in 1906 by Peckett & Sons at their Atlas Engine Works. The *Lord Salisbury* was sent to Radstock Colliery in 1950 and then to Norton Hill Colliery in 1953, from where it was scrapped in 1965. Standing on the footplate is engine driver Bert Cook (1874-1957), whose son Leslie eventually worked on the engine with his father. Jack Shaw, who is standing on the track, started as a fireman on the Frog Lane railway in the 1930s. A three-man team of driver, shunter and fireman operated the engines.

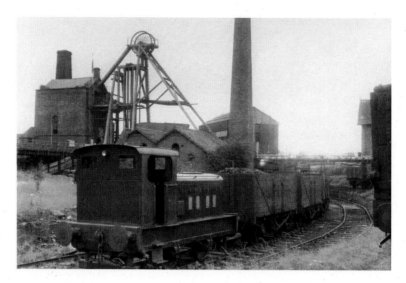

The Ruston and Hornsby diesel locomotive, purchased by the Coalpit Heath Coal Co., pictured not long after its arrival at Frog Lane Colliery in 1946. Photographed by the manufacturer, the class 88DS four-wheel diesel mechanical, works number 242869, replaced the steam locomotive *Lord Salisbury* and, whilst not as strong as its predecessor, had a reputation for being more reliable. Jack Shaw drove the locomotive during its short working life at Frog Lane Colliery, after returning from Second World War service with the Royal Engineers.

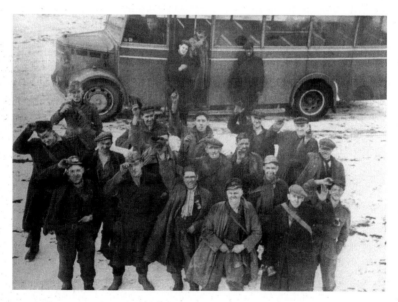

When Frog Lane Colliery closed in 1949, a number of local miners continued to work in the industry in the North Somerset coalfield, and later at Harry Stoke. This group of miners are gathered by the Rambling Rose coach that transported them daily to Pensford Colliery. The following men have been identified: Alfred Smith (in coach doorway), George Smith (leaning against coach), Charlie Smith (centre, back row, without cap), Graham 'Tom' Brown (far left, middle row, doffing cap), Len Eacott (centre, middle row), Frank Smith (face hidden behind cap). From left to right, front row: Arthur Smith, Fred Smith, -?-, -?-, Alec Batten, Harold Gifford. Other names annotated on the reverse of the original photograph are, back row: Oliver Gifford, Eddie Williams and G. Gingell. Middle row: Alb Langley. Front row: Sid Eastman, F. Britton?.

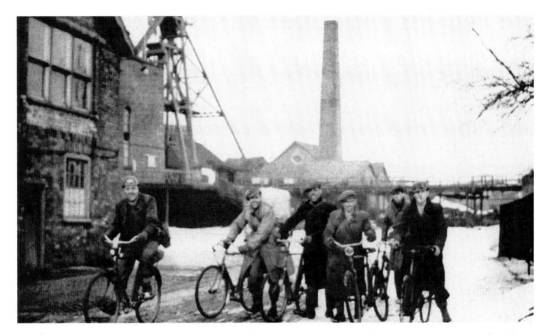

A group of coal miners leaving Frog Lane Colliery in October 1947. From left to right: Arthur Smith, Frank Smith, George Smith, Frank Britton, Charlie Smith, Fred Smith. The building on the left is the weighbridge and colliery office, from where wages were paid by clerks George Blackman and Les Brown. The pit head, engine house and boiler house are in the background.

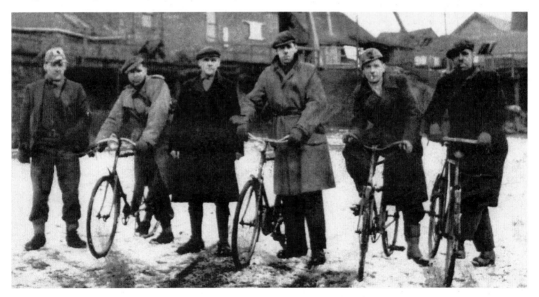

The Smith family, father Alfred and his five sons, pose for the camera on a winter's day at Frog Lane Colliery. From left to right: Arthur, Frank, Alfred, Charlie, Fred and George. Alfred Saunders Smith, born in 1886 in Somerset, worked at New Rock Colliery, Oakhill, before moving to Frampton Cotterell. He married Sarah Rosina Carpenter in 1910. Their five sons followed Alfred down Frog Lane pit, where he worked as an ostler, taking care of the pit ponies underground. Charlie Smith, born 1918, served with the 5th Gloucesters during the Second World War and was one of 98,000 British soldiers evacuated from the beaches at Dunkirk in 1940.

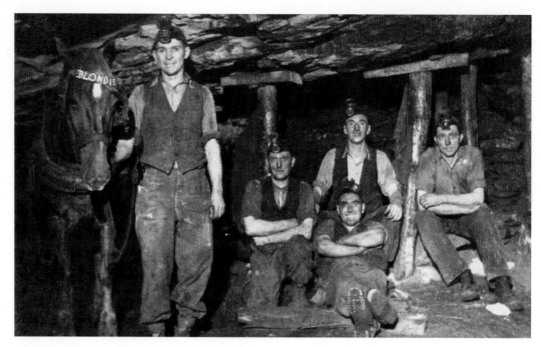

Frog Lane 'horse boys' and one of the pit ponies. This photograph was taken underground by Victor Hawkins of Pucklechurch, five or six years before the closure of the colliery in 1949. From left to right: 'Blondie', Raymond Gifford, Vernon Lewis, Frank Britton, Bill Clark, John Mills. At the peak of the industry in 1913, there were 70,000 ponies underground in Britain. Typically working an eight-hour shift each day, ponies normally pulled empty and full trucks on the underground dramways that led to the coal face and the pit bottom. Geldings were preferred, while mares were uncommon underground.

Gloucestershire Education Committee.

EDUCATION FOR MINERS

A PREPARATORY

MINING COURSE

WILL BE HELD AT THE

Council School, Frampton Cotterell

COMMENCING ON

MONDAY, OCTOBER 6th
1924

Instructor: Mr. Chas. H. Tipton

THE CLASSES WILL MEET AS FOLLOWS :

English - - - *Monday, 7 to 8 p.m.*
Elementary Science - *Monday, 8 to 9 p.m.*
Calculations - - *Wednesday, 7 to 8 p.m.*
Drawing - - *Wednesday, 8 to 9 p.m.*

Admission fee 1 /-

Attendance at a preparatory course is a necessity for any Mining student who wishes to attend the Saturday Classes for miners at the Merchant Venturers' Technical College, Bristol, and such students are advised to join the classes at Frampton Cotterell when they open on October 6th.

Further particulars may be obtained from

COUNCIL SCHOOL, **Mr. CHAS. H. TIPTON,**
 FRAMPTON COTTERELL.

A Gloucestershire Education leaflet, dated October 1924, advertising education classes for miners at a fee of 1s. Mr Charles Tipton, headmaster of Frampton Cotterell Council School, provided hour-long instruction in English, Elementary Science, Drawing and Calculations.

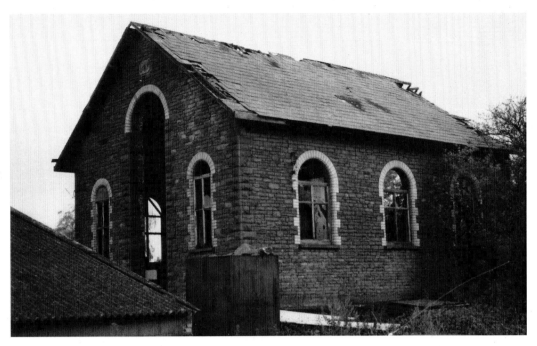

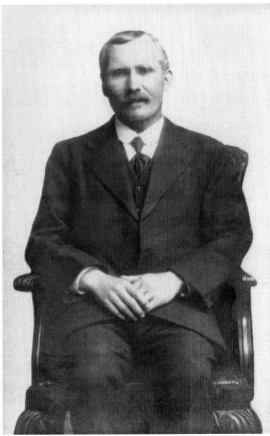

The sad sight of the derelict winding engine house – at the time, the last remaining substantial building of the Frog Lane Colliery. Built in 1886, this building was once the nerve centre of the colliery, only to be destroyed in 2004 with no regard to its importance as part of the industrial heritage of Coalpit Heath.

Joseph Emes, born in 1865 at Little Sodbury, the son of James and Ann Emes, married Adelaide Jemima Sage of Pucklechurch in 1889. The couple lived in Clyde Road, Frampton Cotterell. Adelaide, born 1871 at Pucklechurch, the daughter of Silvester and Sarah Sage, died in 1950 in Lancashire. An elder sister, Phoebe Elizabeth, married John Henry Hunt, manager of the Co-operative Stores in Woodend Road. A coal miner at Parkfield Colliery from at least the age of sixteen, Joseph returned to mining at Coalpit Heath as a miners' check-weighman. He was the local agent for miners and president of the Bristol Miners' Association. He died 5 March 1925; a memorial to him at the entrance to the Wesleyan Methodist Chapel in Church Road was moved to Coalpit Heath churchyard when the chapel was demolished in 1967.

Fred Woodruff, born 21 January 1927, left school aged fourteen to work at Baker's Farm in Park Lane. At the age of eighteen he was drafted into the mining industry as a Bevin boy (young men conscripted to work in the coal mines), training at Pensford in North Somerset and then working at Frog Lane Colliery until its closure in 1949. After a number of jobs, Fred found employment with Drew Brothers at Court Road, where Bill Drew instructed him in the manufacture of coffins. Following spells at Newmans of Yate and Chipping Sodbury Council, in 1967 Fred returned to the funeral business, setting up the company F. Woodruff Esq., funeral director. Fred is pictured, left, with Coalpit Heath CC Chairman Graham Morgan (centre) and David Constant, the former Kent and Leicestershire cricketer and test umpire.

Former Coalpit Heath coal miner Frank Thornell, on the right, with Dave Clark, secretary of the Sodbury Vale Homing Society, at their annual presentation evening. Pigeon fancying was the traditional pursuit of many coal miners, and was one of Frank's favourite pastimes.

On leaving school at the age of fourteen, Frank was employed at Robinson's, Fishponds before being trained as a coal miner at Old Mills, Paulton. He completed his underground mining days in Harry Stoke when the pit closed in 1963. Frank then did ten years open-cast work at Yate. He was both an excellent cricketer and footballer, playing for Coalpit Heath Cricket Club, and Frampton Cotterell and Iron Acton football clubs. Frank's talents were not confined to sport, as for a number of years he played the guitar in Slim Hendy's original band The Toffs.

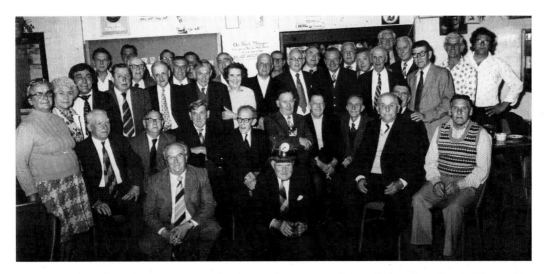

From 1978, for about five years, annual reunions for miners who worked at Frog Lane Colliery were organised by Ray Crich and Fred Woodruff. This gathering at Coalpit Heath Cricket Club (the former Manor School canteen) in April 1978 was attended by over thirty former colliers. Standing from left to right: Mrs Annie Thornell, Mrs Ida Dee, David Dee, -?-, Arthur Moss, Colin Dando, Roy Derek, Henry Woodington, -?-, Trevor Wilcox, -?-, Eddie Thrush, Roly Penton, Mrs Hilda Thrush, Herbert Brille?, Bert Shaw, -?-, Bill Morris, -?-, Alistair Tovey, Ernie Wilcox, Cyril Batten, Trevor Dando, -?-, Edmond Felix, Graham Brown, Colin Dee. Seated: -?-, Leslie Cook, Bob Wilcox, Mr White, Les Davis, -?-, 'Nobby' Clark, Alec Batten, Harry Cryer, Arthur Smith. Kneeling: Fred Woodruff, Charlie Thornell.

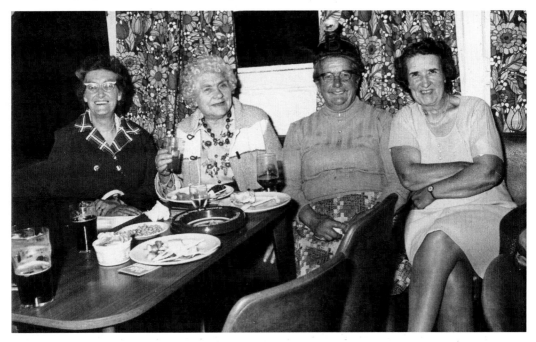

Also invited to attend the reunion were these ladies, who worked in the canteen at Frog Lane Colliery. From left to right: Mrs Wren, Mrs Ida Dee (canteen manager and mother of miners David and Colin Dee), Mrs Annie Thornell, Mrs Hilda Thrush.

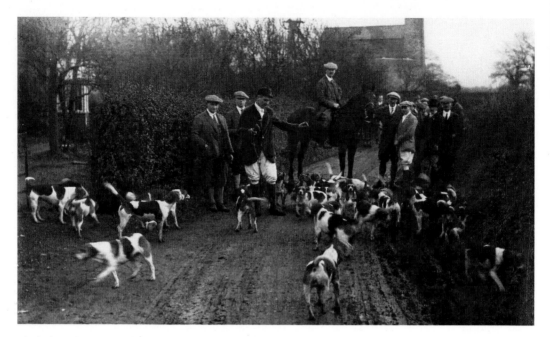

Thought to be a meet of the Wick and District Beagles, sometime in the 1930s, prior to working the fields in the vicinity of Say's Court Farm. Here they are photographed with their followers in the lane leading to Mayshill Colliery – the headgear, engine house and chimney of which can be identified in the background. The gentleman on the horse is believed to be George Bennett of Say's Court Farm.

An adit is an underground tunnel built for the purpose of draining coalfields, taking water from coal pits by gravity to discharge at the lowest point possible into the local river. There are several such tunnels below the surface of Coalpit Heath, traversing the length of Coalpit Heath from Mayshill to Henfield, and then under Kendleshire to discharge into the River Frome. This particularly fine example of such construction was exposed during excavations for a new lake at Serridge.

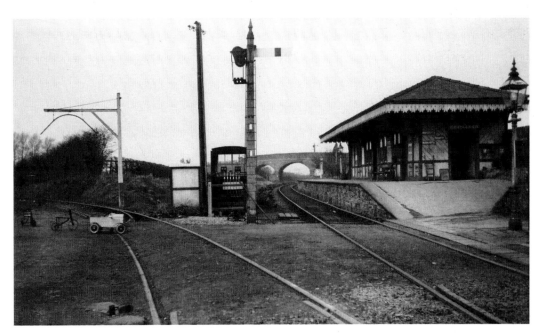

The single-platform Iron Acton railway station in the 1930s, with the line heading towards Thornbury. Curving off to the left is the 1 mile 7 chains of former mineral line to Frampton Cotterell, opened in May 1868. The railway was constructed to carry iron ore from the iron mine on an embankment to the east of St Peter's Church. There were intentions to build a passenger station at Frampton Cotterell, but trains ceased running in 1877 and the track lifted in 1892.

In February 1868, the Gloucester Railway Carriage & Wagon Co. supplied the Frampton Hæmatite Mining Co. with twelve 10-ton wagons for iron ore traffic. This is wagon No. 1, photographed by the company at its works, and is different from a coal wagon as it only has a single plank. The Frampton Hæmatite Mining Co. worked the iron mines in Frampton Cotterell between 1866 and 1870. They would have benefited from the opening of the railway in 1868, which gave direct access from the mines to their customers without the need to tranship at Yate.

The front page of the particulars of sale of iron and coal mines at Frampton Cotterell, Iron Acton and Rangeworthy, and their associated plant, machinery and engines. A public auction was held on 24 July 1869. The iron mines, formerly owned by the Chillington Iron Co. – one of the largest iron companies in Wolverhampton, who worked the mines in the early 1860s –were being sold by the Frampton Hæmatite Mining Co.

GLOUCESTERSHIRE.

VALUABLE MINING PROPERTY.

PARTICULARS

OF THE

FREEHOLD AND LEASEHOLD

COAL & HŒMATITE IRON MINES

AND OTHER PROPERTY,

SITUATE AT

FRAMPTON COTTEREL, IRON ACTON,

AND

RANGEWORTHY,

IN THE COUNTY OF GLOUCESTER,

Formerly belonging to the "Chillington Iron Company," and now belonging to and carried on by the "Frampton Hæmatite Mining Company." Together with the

POWERFUL ENGINES, MACHINERY, AND PLANT,

in full working order.

Which will be offered for Sale by Public Auction,

AT THE BELL HOTEL, GLOUCESTER,

On SATURDAY, the 24th day of JULY, 1869,

AT THREE O'CLOCK IN THE AFTERNOON,

(Either together or in such Lots as may be determined upon at the time of Sale, and subject to such Conditions as may be then produced.)

MESSRS. BRUTON AND KNOWLES,

AUCTIONEERS.

The Mines are about Two Miles distant from the Yate Station upon the Midland Railway, and a Branch from the Yate and Thornbury Branch Railway terminates upon the Property at Frampton, whilst the Yate and Thornbury Branch will pass through the other Property.

Copies of these Particulars and farther information may be obtained of the AUCTIONEERS, Albion Chambers, King Street, Gloucester; at the Offices, at Frampton Cotterel; and at the Offices of

Messrs. DODDS & TROTTER, Solicitors, No. 6, Pall Mall East, London, S.W., and Stockton-upon-Tees.

[25327—24-7-69.]

THE FRAMPTON COTTEREL, IRON ACTON, & RANGEWORTHY

IRON AND COAL MINES.

CATALOGUE OF MACHINERY, PLANT, &c.

PART 1.—THE FRAMPTON WORKS.

FOUR BOILERS IN BOILER HOUSE COMPLETE.

CHIMNEY STACK, &c

TROUGHS AND FLUES FOR AIR SHAFT TO SINKING PIT.

PUMPING AND WINDING MACHINERY.

1 Pair of Horizontal Pumping Engines, with 12-in. cylinders and all necessary gearing for working a pair of 14-in. pumps. The Engines are also adapted to work the capstan.
1 Pair of 14-in. 90 yards lift, with stays, pump rods, &c., complete.
1 large Pumping Engine, Cylinder 70-in. diameter, 18-ft. stroke, with wrought-iron pumping beam and cast-iron balance beam, to work 23-in. ram and 26-in. open lift, 80 yards each.
4 40-horse Boilers, 30-ft. long 7-ft. diameter, 3 internal flues, 2-ft. 9-in. diameter, with all necessary mountings, steam and water pipes, valves, gauges, &c.
1 Ram Pump, 23-in. diameter, 78 yards, with the necessary rods, stays, &c.
1 26-in. Open Lift Pump, with all necessary rods, &c.
1 strong Head Gear Frame, with all necessary pullies, ironwork, rope, &c., with foundation sleepers.
1 Horizontal Pumping Engine, with 18-in. cylinder, 4-ft. 6-in. stroke, fixed and connected to four 12-in. pumps complete, with steam pipes from boilers.
1 Winding Engine, with 2nd motion and drum complete—cylinder 12-in.
1 Donkey Engine (by Cameron), 2 cylinders 7-in. diameter, 2 5-in. Rams, with about 20 yards of suction pipe 4-in. bore, with check clack.
1 Extra Capstan Engine, attached to its own boiler, and fitted to capstan drum—pair of cylinders 10-in. diameter.
1 10-horse power Portable Engine, by Fowler, of Leeds, fitted with drum complete for winding.

MINING MATERIALS.

About 26 tons of Rails.
30 Trams (6 tons).
300 yards flat Chain.
10 tons Tram Plates.
3 Winding Cages.
3 Horse Whims complete.
3 Whim Ropes.
1 Hand Winding Gear.
3 do. do. Ropes.
6 Kibbles.

1 No. 1 Pit Frame, with capstan complete.
1 No. 2 do. do. and rope.
20 Sinking Bowks.
3 Iron Water Barrels.
1 Iron Lander.
2 Pit Top Machines.
2 Pair Iron Winding ditto.
1 Pile Driving Frame.
2 Pit Top Wagons.

3 12-in. Pumps and 1 10-in. Pump, 60 yards deep, with pipes, rods, connections, &c.
1 Horizontal Pumping Engine, 18-in. Cylinder, fixed and connected to Pumps complete.
Railway Sidings, Crossings, &c.
1 Winding Engine, 12-in. Cylinder, with Drum, &c., complete.

BRICK YARD.

Clay Mill Pan, 8 feet diam., Rollers 4 feet diam., fixed on Brick and Stone foundations.
Friction Crane, new, not yet erected.
Engine with 10-inch Cylinder Boilers and Pipes complete,
with 6-inch driving strap, firing tools, &c.
Iron Cistern with Pipes, Valves, &c.
Engine House and Mill Shed (Brick and Tile).
Drying Shed (Brick and Wood)
11 Fire holes, Flues, Chimney, &c., complete.
Round Kiln, with metal Fire Holes, Tie Bands, Flues, and Chimney, &c.
Rectangular Kiln holding 30,000 bricks.

PART 2.—THE ACTON LODGE AND MUDGEDOWN IRON MINES,
CONSISTING OF TWO SHAFTS.

1 Pair of Horizontal Engines, with 8-in. Cylinders and Gearing, for pumping and winding.
1 Boiler for same, with Injector and other fittings fixed.
1 Winding Engine attached to
its own Boiler, with pair of 10-in. Cylinders.
1 Portable Engine, by Robey & Co., with Strap.
2 Lifts, 10-in. Pumps, 50 yards, with L logs, Connecting Rods, &c., &c.
2 Head Gear Frames, with Pullies, Ropes and Capstan Frames complete.
Buildings, Engine Houses, Boiler Houses and Shops.
Sleepers, Rails and Chairs in Siding.

PART 3.—THE RANGEWORTHY COLLIERY.

Engine House and Chimney.
Engine (with Indicator) and Pump, and fixed complete with Boiler.
Water Tank, with Pipes and Valve.
Pit Frame, with Pullies, &c., complete.
190 Yards Wire Rope.
Lead Pipes.
Shaft, 147 yards, with Air Shaft and Coffer Dam.
Weighing Machine.

[25327]

The majority of plant and equipment being sold at the auction belonged to the Frampton Works, and included an array of pumping and winding machinery, mining materials and engines.

9

TRADE AND INDUSTRY

Alec Brown, of Harris Barton, proudly poses alongside a motorised bread delivery van belonging to John Palmer Watts, baker of Frampton Cotterell. William Davis (1845-1933) started a bakery business in Bristol Road, and then had new premises built at No. 227 Church Road (then Church Lane). On his retirement the bakery was taken over by his son-in-law John Watts, who had married Lavinia Hester Mary Davis in 1901. The bakery was later run by the Eaves family, but the Watts family continued to live in the house for many years.

Henry Rogers & Sons' Scammell lorry 'Britannia', with a funfair ride in tow, waiting to enter a show field at Bradford-on-Avon, *c.* 1948. Henry Rogers, from Chipping Sodbury, bought land adjacent to the old hat factories in Park Lane from the Skinner family in 1945 – the yard was a place for the Rogers family to stay once the funfair season was over. Among the structures demolished in Skinner's Yard when Henry and Agnes Rogers and their family moved in was a building that housed a mortuary (presumably used by Mr Skinner, a carpenter, for funerals).

Albert 'Albie' Rogers pictured with a restored Scammell transporter named 'Supreme', which he drove as a seventeen year old in 1948. Built into the rear of the lorry is a chain-driven generator used to provide power for the funfair rides. Lorries of this type were capable of pulling three trailers, but more usually hauled two. Kevin Gamlen of Pensford restored the vehicle, originally owned by Albie's grandfather George Rogers, winning the Vintage Spirit Cup for Best Preserved Scammell (for a vehicle other than a Showtrac) in 2007.

John Palmer Watts, feeding his faithful companions, took over William Davis' Frampton Cotterell bakery in Church Road in the early 1900s. John, the son of Thomas and Martha Watts, came to Frampton Cotterell when his father, a farmer, moved to Frome. By 1891 John was apprenticed to a grocer in Oldland, and ten years later he became a grocer's assistant in Mangotsfield. He died in 1959.

The Mini Market shop, Badminton Road, was developed over a number of years by Mr and Mrs Albert Nash from what was a corner shop owned by Mrs Catherine Birks. Nash's shop sold everything from groceries to newspapers but also had a reputation for excellent quality bacon and home-cooked ham. Additionally, they offered a home-delivery service, which was very popular in the village and surrounding area. Following their retirement the ownership of the shop was taken by Philip and Susan Lear, who are photographed outside the shop around 1990, with their assistant Mrs Margaret Davis in her white apron. Supermarket competition, coupled with a change in shopping habits, brought about the store's eventual demise as a viable business. It is now a hairdressing salon.

Village Roots opened in June 1989 as a co-operative, to replace the Frampton Cotterell Co-operative Society shop. It was officially opened by sisters Muriel Axford and Marion 'Mollie' Holway. Their father, William Henry Lewis, was a founder member of the Frampton Cotterell and District Co-operative Society. The shop title remained for fifteen years until 2004, when Village Roots, whilst remaining an independent trader, became a member of the National Independent Supermarket Association (NISA).

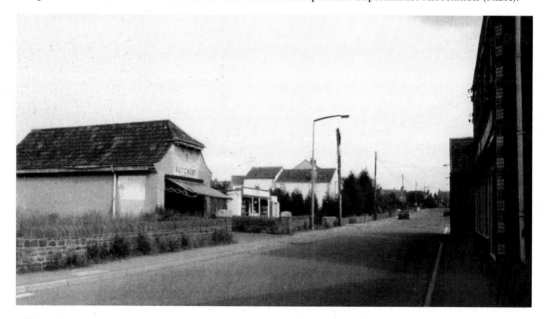

The Co-op butcher's and former hardware shop in Woodend Road, which stood on the opposite side of the road to the main store, photographed 8 June 1984. Frampton Cotterell and District Co-operative Society, founded in 1894, joined the Bristol and District Association on 27 August 1898. By 1900 they had 230 members and were involved in a range of business activities: flour, bakery, grocery, coal, drapery, tailoring and ironmongery. They also had a branch in Easter Compton.

In 1971 the Co-op hardware shop was taken over by Peggy Crew, who ran the business with her husband Richard until 1986, when the building was demolished. The site was sold for housing development and the area is now occupied by bungalows. The road to the right of the shop is The Land.

The Co-operative Society Hall, Woodend Road. This photograph was taken in January 1983, prior to the hall being demolished for new development. The hall was used for many functions, including dances and wedding receptions. At the rear of the building on the ground floor, underneath the function room, was the Co-op's bakery. The minutes of the Gloucester Co-operative Society committee meeting, dated 28 December 1898, record that an invitation had been received 'cordially inviting two delegates to attend the opening of the New Bakery in Frampton Cotterell at 2.30pm for Tea and a Public Meeting'.

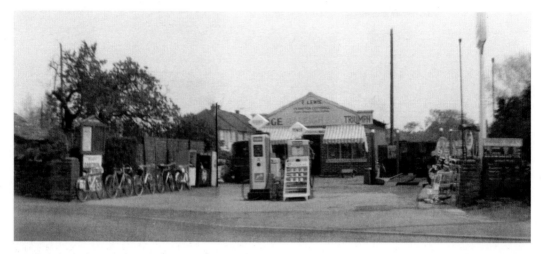

Edgar Lewis' 'Frampton Cotterell & Coalpit Heath Car Hire, Service and Cycle Depot', situated at the junction of Woodend Road and Lower Stone Close. On leaving employment at the Parnall Aircraft Company in 1946 to start his own business, Edgar Lewis rented a small shop opposite Zion Chapel (No. 32 Woodend Road) from Ivor Skidmore, opening the Frampton Cotterell Cycle Depot. In 1951 Edgar moved the business to the location in the photograph and erected a larger shop, from where he conveyed many local couples to their wedding in an Austin 16, Austin 18 or Wolseley motor car. Edgar's son, Michael, joined the business on leaving school in 1954, repairing and servicing mopeds and motorcycles; his daughter Christine, from 1960, served in the shop and dispensed petrol (National Benzole) to motoring customers. Edgar retired just before decimalisation in 1971, Christine a year later, with Michael continuing at the garage for servicing, repairs and breakdown until his retirement in 2008. A new garage now occupies the site.

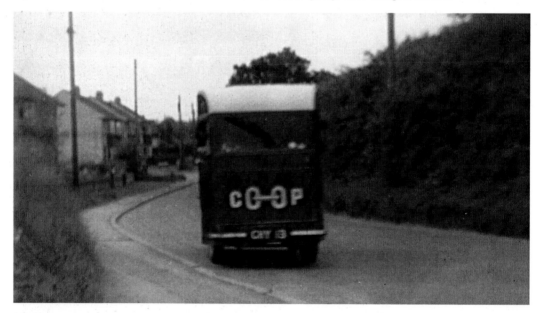

A Co-op electric bread delivery van on its round near the Star Inn, Watermore Lane (now Church Road) before the road improvements of 1961. The driver is Brian Penney. Electric delivery vans were a common sight throughout the country for many years. The photograph was taken by Jean Mitchell, daughter of Albert Mitchell, landlord of the Star public house.

The Rising Sun pictured in the 1960s, when beer was supplied to the pub by the Courage Brewery of Bristol. At the time of the photograph the pub was run by Billy Williams from Lockleaze, who took over from Mr and Mrs Albert Gay. The forecourt was the terminus for the Frampton Cotterell to Bristol bus. Bristol United Breweries acquired the pub in Ryecroft Road around 1902 from the Howes family, who ran the establishment as a free house from the 1860s. Gilbert Bisp became licensee following the lengthy tenure of the Howes.

Lewis Herbert Oborne, his wife Evelyn Blanche (née Sims), and daughter Evonne (aged seven) standing in front of his lorry in 1947. Mr Oborne (1902-1970), a building contractor, lived in Rectory Road, Frampton Cotterell. Evelyn, born in Wiltshire in 1899, died in 1983.

Coalpit Heath post office, located on the corner of Church Lane and Woodend Road. Originally two premises, with a sweet shop on the left and a shoe shop on the right, at the time of this 1970s photograph the post office and shop was run by Christopher E. Cavill. The post office was then taken over by G.D. Dacam.

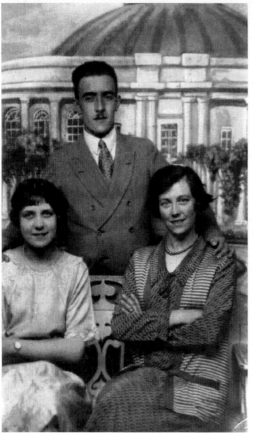

Three of the four children of George Henry Payne (1872-1946) and his wife Florence (née Gifford). Left to right: Ella Nora (1910-2001), Royston George Henry (1907-1983), Rebe Florence Evelyn (1900-1963). George Henry Payne, a grocer and shopkeeper in Coalpit Heath, established a bakery business in the 1890s, which was taken over by son Roy in the 1940s. In 1921, Rebe Payne married Roland John Hale, whose butcher's shop in Woodend Road was opposite Zion Chapel. Roy Payne married Doris Savage in 1930 and Ella Payne wed Harold Thompson in 1933.

After returning to Coalpit Heath following a professional football career with Bristol Rovers, Arsenal, Notts County, Charlton Athletic and Swansea Town, Ron Green established a newsagent shop in Beesmoor Road. Green, a keen cricketer who played for Arsenal's cricket XI, represented Frenchay CC and was later a director of Coalpit Heath FC. In what appears to be a posed press photograph, Ron is depicted delivering newspapers to his customers during the bad winter of 1963.

Green's newsagents, Beesmoor Road. The garage adjoining the bungalow was converted into a newsagent's and tobacconist's shop by Ronald Green after his retirement from professional football and his return to Coalpit Heath. In this photograph, taken around 1995, the current proprietor Shirley Crewe is on the right with her then assistant Hannah Grey.

A Brookman's bakery advert that appeared as part of a feature in the *Gazette* on 30 May 1964. George Brookman, from Pensford, established a family bakery business in Frampton Cotterell in the mid-nineteenth century.

For generations the Brookman family bakery business, based in Church Road, served their customers in Frampton Cotterell and the surrounding area. A change in shopping patterns, the influence of supermarkets, and a need for large investment in order to modernise the outdated equipment, brought about its inevitable closure. At 10.30 a.m. on 25 November 2006, the last loaf of bread by a commercial baker of Frampton Cotterell was taken from the oven, bringing to an end a traditional village craft and trade. John Brookman, on the left, oversees the removal from the oven of the last flat tin loaves by one of his employees, Robert Searle, whose hands are protected by his baker's mittens.

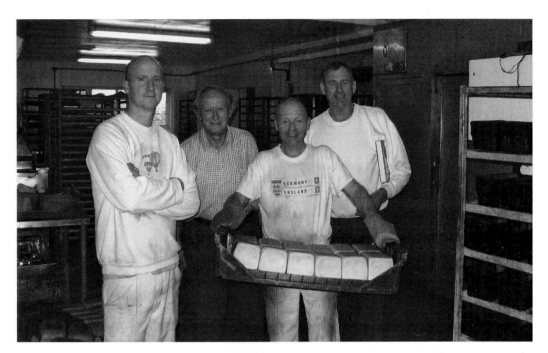

Robert Searle carries the last batch of flat tin loaves, ready for dispatch to the shop at Coalpit Heath. Nick Brookman, son of John, is on the left of the photograph, standing next to his father. Also in the picture is Keith Pearson, another of John's employees.

The empty Coalpit Heath shop of Brookman & Sons awaiting auction on 7 March 2007. The business, based in Church Road, also had shops in Chipping Sodbury, Downend, Winterbourne and this one in Woodend Road, which had previously been the bakery and shop of George Payne.

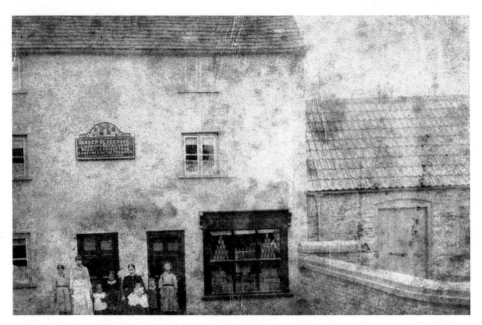

The Bunch of Grapes public house, Brockridge Hill, now Woodend Road. The 1871 census records the Crown Inn at Brockridge (exact location unknown), which may have been an earlier name for the Bunch of Grapes. During Isaac Blackmore's tenancy in the latter part of the nineteenth century, the pub was a tied-house, with beer supplied by Arnold, Perrett & Co., of High Street, Wickwar. As well as being a licensed victualler, Isaac, a former farm labourer, also ran a small butcher's and grocery shop in the same building as the pub. The shop window can be seen on the right of the building. Photographed outside the pub in 1889 are, from left to right: Beatrice Maud Parker Blackmore, Rhoda Buckley (maid), Victoria May Parker Blackmore, Rosina Parker Blackmore, Elizabeth Parker Blackmore with baby Isaac Lawrence Blackmore, William Parker Blackmore, Elizabeth Louisa Parker Blackmore.

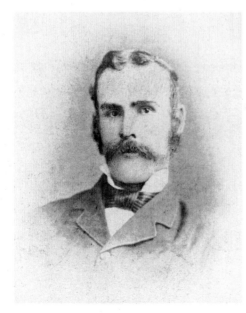

The landlord of the Bunch of Grapes from the 1880s to 1910 was Isaac Parker Blackmore, born 16 August 1856, the second son of William Shedrick Parker and Louisa Blackmore. In 1878 Isaac married Elizabeth Rosina Stone (1857-1942), the daughter of James and Hester Stone. In the 1911 census Elizabeth's place of birth is given as the Ring o' Bells, where her father is recorded as a victualler in the 1851 census. Isaac purchased the old Manor School house when it closed in 1910 and became landlord of the Ring o' Bells, Coalpit Heath, that same year. Isaac died 27 April 1925 at The Bungalow, Station Road; his wife Elizabeth Rosina died in 1942 and both are buried in St Saviour's churchyard. Their son, William Parker Blackmore (1885-1954), took over the pub in the 1920s.

Advertisements from the Frampton Cotterell Yearbook of 1956, including one for Drew Brothers Funeral Services. William Drew, a wheelwright of Court Road, Watley's End, established a business there with his two sons, James Albert and Frank, in 1902 as W. Drew & Sons, Agricultural Engineers and Blacksmiths. Following the demise of William, the business continued as J.A. & F. Drew: Carpenters, Wheelwrights and Undertakers – until J.A.'s death in 1934. In 1952, Albert, Frank Drew's son, purchased premises and land in Mill Lane to set up business there; another of Frank's sons, William, remained at Court Road. Eventually, the Court Road site was sold to a local builder; the timber yard and paddock were developed for housing, with the area that contained the workshop and forge now the site of Rentokil Ltd.

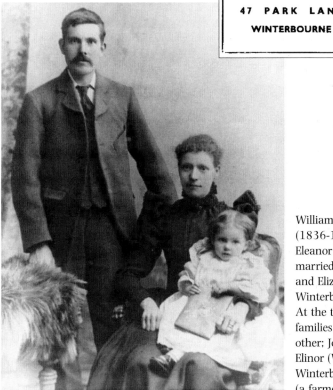

William Drew (1837-1901) and wife Elizabeth (1836-1905) with one of their daughters, Eleanor May. William, from Rangeworthy, married Elizabeth Ivory, the daughter of Lot and Elizabeth Ivory, 24 February 1856 at Winterbourne Church.
At the time of the 1851 census the two families were living in close proximity to each other; John Drew, a carpenter, and his wife Elinor (William's parents) appear on the same Winterbourne enumeration page as Lot Ivory (a farmer of 54 acres) and his wife.

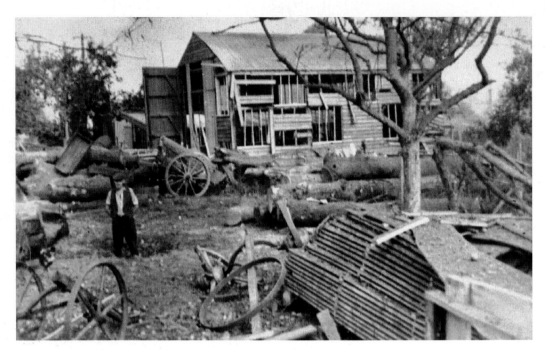

Jack Sales, an employee of F. Drew & Sons, stands in the crater left by a German Luftwaffe bomb which fell into Drew's timber yard in Court Road in 1940. The explosion caused considerable damage to the wooden workshop in the background – and to the firm's timber, which was peppered with shrapnel and debris.

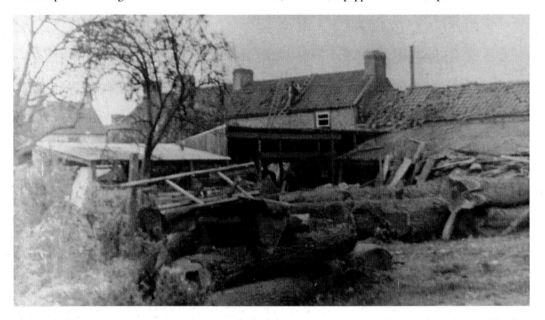

Albert Drew replacing tiles on the bomb-damaged roof of his Court Road premises. It's possible that the air raid took place on the night of 4/5 September 1940, when the Bristol area was attacked by forty-seven German aircraft. Fifteen high-explosive bombs were dropped on Frampton Cotterell, the most significant damage being at Frampton Road (now Court Road) and School Road. The Cross Hands Inn was extensively damaged.

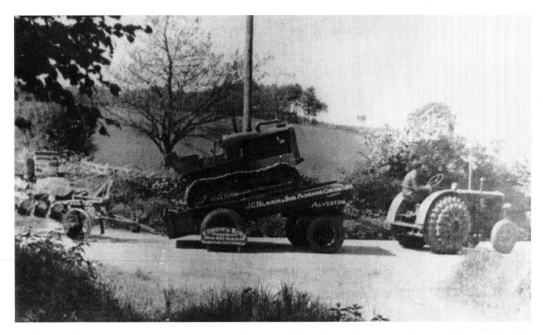

F. Drew & Sons are proud to advertise their manufacturing skills by displaying a trailer that is strong enough to transport a Caterpillar tractor belonging to J. Blanch & Son, ploughing contractors of Alveston. The Massey Harris tractor, registration number EAD 661, not only pulls the Caterpillar along the Old Gloucester Road near the entrance to Grange Farm, but also pulls a four-furrow plough which is hitched to the trailer.

Edgar Thornell, holding the rope and bucket, has been involved in the digging of a well in a field along Perrinpit Road. The successful water dowser in this case is believed to be Mr Goodfield. Dowsing is a type of divination employed to locate ground water using a dowsing rod – traditionally, a forked branch from a tree or bush. The two ends are held one in each hand and often the branches are grasped palms down. The dowser then walks slowly over the places where he suspects the target (for example, minerals or water) may be, and the dowsing rod dips, inclines or twitches when a discovery is made.

Albert Drew observes Harry Hopkins at the controls of a homemade 'Heath Robinson' mechanical cross-cut saw, cutting through a fallen tree trunk. It is thought that Hopkins, of Frampton Mill, made the machine and is demonstrating its use to a potential customer. Health and Safety doesn't appear to be an issue, judging by the abundance of exposed working parts and the fact that Albert is smoking a cigarette near the open fuel tank.

Prior to the introduction of mechanical circular and band saws, timber conversion from tree trunks to sawn planks was carried out by travelling pit sawyers. This photograph, taken in Drew's yard in Court Road, shows two such itinerant men employed by Drew Brothers. The two-man team would use a two-handled saw called a 'whipsaw'; the 'bottom sawyer' stood in the pit and the 'top sawyer' balanced on the log.

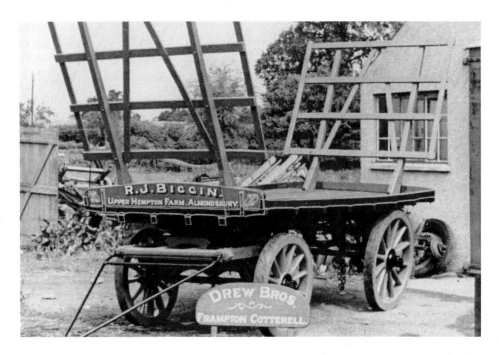

A new wagon bed and hay ladders, constructed by Drew Brothers for J.A. Biggin of Almondsbury. Photographed in late 1942 in front of the newly built blacksmith's workshop in Court Road, the fact that it is wartime may explain why iron-tyred wooden wheels were used instead of pneumatic tyres.

Frank Drew, whose shadow can be seen in the foreground, took this photograph of a typical product manufactured by his company F. Drew & Sons. From an invoice dated 26 November 1941, the new farm putt (cart) with hay ladders was constructed on a second-hand Morris axle and wheels at a cost of £28 10s. Drew's old blacksmith shop in Court Road is behind the putt, with the butcher's shop on Bristol Road in the distance.

If you enjoyed this book, you may also be interested in...

Bristol Rovers: A Season to Remember
IAN HADDRELL AND MIKE JAY

In the 1989/90 season, Bristol Rovers clinched promotion to the old 'Second Division' and set an outstanding club record, remaining undefeated in 41 matches. This remarkable time is remembered with many previously unpublished photographs, interviews with the players, statistics and match reports. Anyone who was there will relish reliving the magic through the memories and illustrations, while those who are too young to recall it can discover the thrill and anticipation that made it a season to remember.

978 0 7524 6448 0

Bristol, City on Show
ANDREW FOYLE, DAN BROWN AND DAVID MARTYN

This unique celebration of life in the city contains a stunning portfolio of new and original views of Bristol's most notable locations. These images are juxtaposed with more than 100 of the rarest engravings and archive photographs. Rich with Georgian splendour and architectural grandeur, Bristol has evolved to meet the changing needs of its residents and visitors.

978 0 7524 7000 9

The Bristol Book of Days
D.G. AMPHLETT

Featuring a story for every day of the year, this collection includes famous historical events – such as the storming of the city during the Civil War and the opening of the Clifton Suspension Bridge – alongside quirky and less well-known tales, such as the poltergeist of the Lamb Inn and the bizarre death of Revd Newnham. This fascinating book is sure to appeal to everyone interested in the rich and colourful history of one of Britain's oldest cities.

978 0 752 4 6038 3

Bristol: A Pocket Miscellany
SARAH COLES

Everything you wanted to know about Bristol ... and more! From the momentous to the outlandish, this book is packed full of fun facts and trivia about everything Bristolian. From celebrity quotations to local people's likes and dislikes, it's all here in this addictive little book. A perfect gift, souvenir or nostalgia purchase.

978 0 7524 5976 9